DEBORAH MARTIN KAO

Gary Schneider Portraits

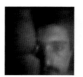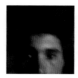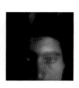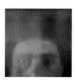

Harvard University Art Museums, Cambridge
Yale University Press, New Haven and London

This catalogue is published in conjunction with the exhibition **Gary Schneider: Portraits** organized by the Fogg Art Museum, Harvard University Art Museums.

Harvard University Art Museums 28 February–13 June 2004

The Contemporary Museum, Honolulu 13 August–10 October 2004

 NATIONAL ENDOWMENT FOR THE ARTS Supported by a grant from the National Endowment for the Arts, a federal agency.

Designed by Daphne Geismar
Set in Eureka and Eureka Sans type by Amy Storm
Printed in Singapore by C S Graphics

Library of Congress Cataloging-in-Publication Data
Kao, Deborah Martin.
Gary Schneider: portraits / Deborah Martin Kao.
 p. cm.
"This catalog is published in conjunction with the exhibition Gary Schneider: Portraits, organized by the Fogg Art Museum, Harvard University Art Museums, 28 February–13 June 2004 [and shown at other museums throughout 2004]"
Includes bibliographical references.
 ISBN 0-300-10054-x (pbk.: alk.paper)
1. Photography, Artistic—Exhibitions. 2. Portrait photography—Exhibitions. 3. Schneider, Gary, 1954—Exhibitions. I. Schneider, Gary, 1954– II. Fogg Art Museum. III. Title.
TR647.K363 2004
779'.2'092—dc21
2003013951

A catalogue record for this book is available from the British Library.

The paper in this book meets the guidelines for permanence and durability of the Committee on Production Guidelines for Book Longevity of the Council on Library Resources.

10 9 8 7 6 5 4 3 2 1

Frontispiece, page 100: Detail of plate 42

The illustrations listed below are reproduced with permission from or courtesy of the following.

Essay: fig. 3 © Jasper Johns / Licensed by VAGA, New York, NY, and courtesy Leo Castelli Gallery, New York; fig. 4 © The New York Times and courtesy John Erdman, Brookhaven, N.Y.; fig. 10 Smith College Museum of Art, Northampton, Mass.; fig. 15 © Alan Ross, Houston; fig. 25 Cover © 2000 *Artnews* LLC, reprinted courtesy of the publisher; fig. 26 © The New York Times

Interview: fig. 6 courtesy of the Peter Hujar Estate, New York

Photography Credits

Reuben Cox, New York: essay fig. 8; D. James Dee, New York: essay fig. 22; Adam Eidelberg, New York: plates 33–38; Imaging Services, Widener Library, Harvard College Library (Stephen Sylvester and Robert Zinck), Cambridge, Mass.: essay figs. 19, 24–26; Laumount Lab (Albert Fung and Estaban Mauchi), New York: plates 20–23; Gary Schneider, Brookhaven, N.Y.: essay figs. 1–2, 5–7, 11–14, 16–18, 20–21, 23, plates 1–32, 39–47, and interview figs. 1–8

The images for *Genetic Self-Portrait* were produced in collaboration with the following scientists and technicians:
Plate 34. *Hair*, 1997, specimen prepared by Professor Stephen Beck. *Chromosomes*, 1997, specimen prepared by Dorothy Warburton, Ph.D.
Plate 35. *Irises*, 1997, specimen prepared by Denise Hess
Plate 36. *Dental Panoramic Radiograph*, 1997, specimen prepared by Pasquale J. Malpeso, D.M.D; *Tumor Suppressor Gene (MLL) on Chromosome 11 and on the Nucleus*, 1997, specimen prepared by Dorothy Warburton, Ph.D.; *Retinas*, 1998, specimen prepared by Denise Hess
Plate 37. *Buccal Mucosa Cell in the Oral Cavity To Show a Nucleus and Mitochondria*, 1997, specimen prepared by Kurenai Tenji, M.D. and Ph.D., in the lab of Dr. Eric A. Schon; *DNA DYZ3/DYZ1*, 1998, specimen prepared by Dorothy Warburton, Ph.D.
Plate 38. *DNA Sequence—The Testis-Determining Gene SRY*, 1997, specimen prepared by Stephen Brown, M.D.; *Mitochondrial DNA Sequence from a Hair Follicle Showing the Respiratory Chain Energy Producing Gene ND1*, 1997, specimen prepared by Claudio Bruno, M.D., in the lab of Dr. Eric A. Schon; *Sperm*, 1997, specimen prepared by Michael Allen, Ph.D.; *Dried Blood*, 1997, specimen prepared by Carole Bergeron, R.N.
Plate 46. *Intestinal Flora*, 1999, specimen prepared by Dr. Barbara Panessa-Warren and Robert Sabatini

Contents

In 1765, Harvard College commissioned a portrait from a rising local painter, John Singleton Copley. Harvard's interest in portraits continued, and in 1869 the university published the catalogue of its Gray Collection of Engravings, formed by a member of the class of 1809. Old-master prints were catalogued by their makers, then a very modern concept, since prints that reproduced paintings, a majority in the Gray Collection, had conventionally been indexed by painters. But the traditional focus on portraits did not lapse. A scan of the Gray catalogue's pages is constantly interrupted by a bold Gothic "𝔭" signaling every portrait print, from Dürer's sober *Erasmus* to Grévedon's luscious *Mallibran*.

One catalogue entry refers to Mr. Gray himself, whose engraved portrait appears as the frontispiece. It stipulates that the artist made the print "with the aid of a photograph by Whipple." Thus even Harvard noticed the beginning of the end for the hand-wrought portrait (except, perhaps, at Harvard, which to this day commissions paintings of its luminaries). By 1869, painted, drawn, and printed faces had begun to be displaced by the silvery daguerreotype and the photographic paper image.

How fitting, then, with this centuries-old focus on the portrait, that the Harvard University Art Museums should now present the photographs of Gary Schneider. His distinct and creative contribution to the genre continues within photography the tradition of a hand-wrought technique. His embodiment of flesh and character, often on a huge scale, is a simulacrum of the intense scrutiny and patient manipulation of light, his tool, which it entailed. Schneider has moved beyond even unconventional representation of surface likeness; in his genetic self-portrait he penetrates to the intrinsic identifiers of the unique individual.

I leave technical description and an eloquent analysis of the pictorial and interpretive consequences of Schneider's method to our author, Deborah Martin Kao. We owe her every thanks: for her initiative, intelligence, and understanding, which illuminate the content of her project; and for her patience, diligence, and good humor, which have brought it to fruition. Throughout, she collaborated with the artist, and she and I both wish to express our gratitude to Gary Schneider for his generous participation. We hope that through this catalogue and exhibition we have enabled a new appreciation for his creative achievement and for the ever-expanding bounds of portraiture.

Marjorie B. Cohn
Acting Director
Carl A. Weyerhaeuser Curator of Prints
Harvard University Art Museums

This exhibition and its catalogue would not have been possible without the unwavering commitment to the project of Gary Schneider and his partner, John Erdman. From the day we met, they graciously opened their studio and home to me and extended their friendship. It was a privilege to pore over images and discuss ideas with them, and a special delight to do so because of their unrivaled hospitality.

Howard Yezerski, who represents the artist in Boston, introduced me to Gary and John in 1996. I admire Howard for always being led by his discerning eye and big heart. I am grateful, too, for the support and assistance of Stephen Daiter Gallery, Chicago; P.P.O.W. Gallery, New York; and Julie Saul Gallery, New York. I am particularly thankful for the enthusiasm of Jay Jensen, curator, The Contemporary Museum, Honolulu, which is hosting *Gary Schneider: Portraits*.

In addition to Gary Schneider, who graciously lent the majority of the works included in the exhibition, the following institutions and individuals kindly made works from their collections available to this project: the Buhl Collection, New York; Richard and Ronay Menschel, New York; Zavie and Ida Miller, Nepean, Ontario; Barry Singer Gallery, Petaluma, California; and the Whitney Museum of American Art, New York.

In pursuing my work on Gary Schneider's photographs I also benefited from the encouragement and insights of Clifford Ackley, Carl Chiarenza, Marjorie B. Cohn, Susan Edwards, Barbara Hitchcock, Robin Kelsey, Michelle Lamunière, Richard L. Menschel, Sarah Miller, Linda Norden, Mary Panzer, Herbert Pratt, Belinda Rathbone, Edward Saywell, Elizabeth Siegel, Ann Thomas, Jenna Webster, Caroline Cunningham Young, and Alice Sachs Zimet.

Heidi Downey, Patricia Fidler, Michelle Komie, and Mary Mayer of Yale University Press and Evelyn Rosenthal and Marsha Pomerantz of the Harvard University Art Museums produced and edited this catalogue with enviable skill and insight. The book's elegant design, by Daphne Geismar, reflects the high standards of the production staff at Yale and their acute awareness that the meaning of Schneider's work often hinges on subtle modulations of color, tone, and form.

Museum work is a highly collaborative enterprise, and I am enormously grateful to work with a talented and dedicated group of colleagues at HUAM. I owe special thanks to Michael Dumas for his assistance and for his unfailing sense of humor. Craigen Bowen, Anne Driesse, and Penley Knipe expertly prepared the art for installation and tour; it was beautifully designed by Steve Hutchison and installed by Danielle Hanrahan and her skilled staff. Susannah Hutchison, Stephanie Schilling, Marsy Sumner, and Rebecca Wright provided a wide range of administrative support. Maureen Donovan and Francine Flynn oversaw the exhibition tour.

Beyond all else, the success of *Gary Schneider: Portraits* depended on the unstinting support of James Cuno, formerly Elizabeth and John Moors Cabot Director, and Marjorie B. Cohn, acting director of the Harvard University Art Museums. They have continued the institution's commitment of more than thirty years' standing to contemporary photography through exhibition, acquisition, and publication.

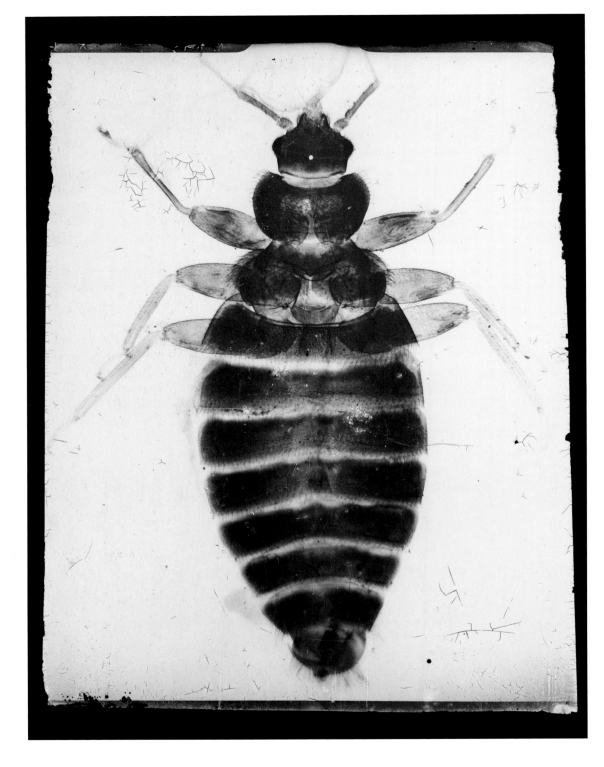

The Obsession of Looking at Things Up Close

DEBORAH MARTIN KAO

South African–born photographer Gary Schneider made a remarkably revealing comment to an interviewer when speaking about his 1987 breakthrough series *Entomologicals*. For this body of work Schneider had fashioned highly interpreted 38-by-28 $\frac{1}{2}$- inch gelatin silver prints from 4-by-3-inch nineteenth-century dry-plate glass negatives depicting insects or parts of insects (figs. 1–2). When he found the negatives — at a garage sale, while on a vacation in the Caribbean — he immediately responded to them as tantalizing objects in themselves and for the creative possibilities they held. Schneider supposed that an amateur scientist had made the negatives by placing the lens of a camera to the eyepiece of a microscope. They so captured Schneider's imagination that he conjured up their nineteenth-century maker as a "colonial, stuck there without anything to do but to live inside of his microscope."

Viewing Schneider's titanic *Entomologicals* in fact approximates the visceral experience of peering through a microscope, where the visual field is saturated with unnatural opalescent light and the commonplace is revealed as an exquisitely alien world. But Schneider's rumination regarding the authorship of the antiquated insect negatives stems more from projection than historic fact, as he freely confessed to his interviewer: "I think being a colonial was like being inside of a microscope. I've inherited, in being South African, the obsession with looking at things up close. This is what all my work is — looking at things really up close."[1]

Since 1987 Schneider has lived inside his own metaphoric microscope, focusing obsessively on worlds of his own making, exploring what he calls the "layered narrative of my life as subject. Like the scientist, I take my subject into the laboratory to treat it as a specimen, drawing from it in order to make it yield how it functions for me."[2] Schneider describes the *Entomologicals* as a type of self-portraiture in which he assumed authorship of the negatives. "I became interested in reinventing history for myself," he said. "I presumed to obliterate the author in order to reinterpret the negatives as my own, thus revealing something of myself in the process."[3] By such uncon-

FIG 1
Unidentified photographer
Untitled (microphotograph of an insect), c. 1880
Source for *Entomological #2*
Gelatin silver dry-plate glass negative
4 x 3 inches (10.2 x 7.6 cm)
Collection of Gary Schneider

FIG 2
Entomological #2, 1987
Gelatin silver print
38 x 28 $\frac{1}{2}$ inches (96.5 x 72.4 cm)

ventional means of self-exploration Schneider has reinterpreted the parameters of the portrait photograph, creating a diverse array of provocative works that probe the unstable and enigmatic character of identity.

Theater of the Conceptual

The fascination with biology, the fetishistic regard for the found object, and the passionate absorption with biography and autobiography evinced in the *Entomologicals* and throughout Schneider's mature work are rooted in American postminimal conceptual art of the 1970s, on which Schneider was "weaned," as he put it.[4] For a shy, dyslexic, gay Jewish youth, the conservative and isolationist South Africa of the 1960s and 1970s was psychologically oppressive. By the time Schneider enrolled at the University of Cape Town in 1975, the world of art and ideas had begun to provide an essential reprieve, allowing him to construct and control a space of his own, a place in which to contemplate his multiple outsider identities and "make contact with people in some very essential way rather than by social contract."[5] During this period he read voraciously as the ascendant conceptual art scene in America was debated on the pages of *Artforum* under the editorship of John Coplans and chronicled in such books as Lucy Lippard's *Six Years: The Dematerialization of the Art Object from 1966 to 1972*.[6] Schneider's earliest significant work, made while he was an art student in South Africa, demonstrates how he absorbed and laid claim to the visual vocabularies and intellectual strategies of what Robert Pincus-Witten characterized as the "theater of the conceptual" in his well-known 1973 *Artforum* essay of the same title, a tract that profoundly affected Schneider at a critical moment in his development.[7]

In that essay and others for *Artforum*, Pincus-Witten set out to define a type of conceptual art impelled by autobiography and forming a trajectory from Marcel Duchamp to Jasper Johns to Vito Acconci, Bruce Nauman, and others. Central to Pincus-Witten's thesis is the notion that these artists are linked by the way they deduce "empirical representation . . . from diagrammatic terms" and use the "body as medium"

to explore phenomenology and behavioral aspects of performance. He traced these concerns back to three small-scale, sexually suggestive sculptures—*Dart-Object*, *Female Fig Leaf*, and *Wedge of Chastity*—that Duchamp made around 1950, Johns owned by 1960, and Acconci acknowledged as a source for his sensational *Seedbed* installation-performance at New York's Sonnabend Gallery in 1972—when he literally sowed his seed through "private sexual activity" beneath a wedge-shaped wooden ramp on which the audience could walk.[8]

Duchamp's sculptures render male, female, and combined male-female sexual forms, respectively, and, as Pincus-Witten notes, they are related to the artist's *Étants Donnés*. That darkly erotic peep-show tableau that Duchamp famously constructed in secret between 1946 and 1966 in a New York loft was permanently installed at the Philadelphia Museum of Art in 1969. *Étants Donnés* is a realistic sculpture of a supine nude female—leather stretched over a metal armature—set in a landscape. Duchamp's small sculptures derive from this female form, either as byproducts or as direct casts from it. Pincus-Witten conjectures that the sculptures, amplified by the signature wordplay in Duchamp's title for the phallic-shaped *Dart-Object* ("objet d'art" or "object of the dart"), were an essential source for Johns's 1955 *Target with Plaster Casts* (fig. 3) and, by extension, for other examples of conceptual body-fragment art, such as Bruce Nauman's 1967 wax-and-cloth molded sculpture *From Hand to Mouth*. "Taking Duchamp's pun literally, at face value," Pincus-Witten wrote, "Johns inaugurated an imagery of conceptual ambiguity," and the body fragment thus emerged as an "insistent intellectual clutch" for autobiographical conceptual art.[9]

Schneider aligned himself with this trend in 1975, when, as a twenty-year-old art-school student, he made two pairs of fragmented portrait photographs with a 35mm camera; they are among his earliest extant works. *Portrait of Ralph* and *Assisted Self-Portrait* (see plates 1, 2) each comprise sixteen postcard-size gelatin silver prints that illustrate details of the body at their actual size—mouths, eyes, toes, nipples,

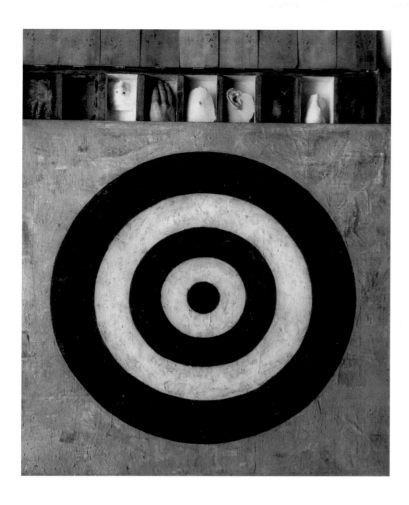

skin, hair, buttocks—arranged side by side in several rows but without a prescribed order. These close-up views titillate through their implication of intimacy and their ambiguity. The particulars of the bodies they depict are at times difficult to discern and call to mind something unrelated to human anatomy. Veins and arteries beneath taut skin in *Assisted Self-Portrait*, for example, look like leaves—botanical rather than zoological. While Schneider makes obvious reference in the portraits to both Duchamp's and Johns's molded body parts, he comes closest to Acconci in the way he conceives of them as performance pieces about his own sexuality.

As Schneider sees it, Acconci used his body in *Seedbed* as a "medium to perform a private act in a public space as a pure act of communication." Acconci's piece wholly influenced Schneider's approach to the fragmented portraits, in which, he said, "I used my body both as a unit of measure and as a means to display my narcissism, while making a narrative on my sexuality . . . pitting myself against the specter of the police state."[10] The performance aspect of the fragmented portraits involved Schneider's specifying the camera's focal length and then using the apparatus to examine the nude body of his friend Ralph, after which he directed Ralph to do the same thing to him. Schneider then repeated the process with a woman named El. The subject of these pieces is the private act of close observation that is made public after the event through the display of the photographs. In effect, Schneider's fragmented portrait photographs represent the consequences of scripted actions he preconceived and directed; in Pincus-Witten's phrase they are the "empirical representation deduced from diagrammatic terms."

In the winter of 1975–76, following his work on the fragmented portraits, Schneider visited New York for the first time and "saw everything I could. Every program at the Collective for Living Cinema, Anthology Film Archives, the Kitchen, as well as every exhibition and much of downtown theatre. I went to Philadelphia to see the Arensberg collection of Duchamp, and after badgering Vito Acconci he generously agreed to meet with me."[11] A year later Schnei-

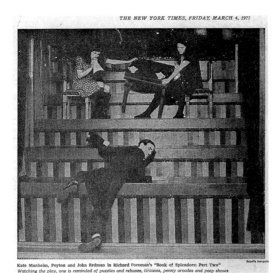

Kate Manheim, Peyton and John Erdman in Richard Foreman's "Book of Splendors: Part Two"
Watching the play, one is reminded of puzzles and rebuses, circuses, penny arcades and peep shows

FIG 4
John Erdman, Kate Manheim, and Peyton Smith performing in Richard Foreman's *Book of Splendors: Part Two*, 1977, at the Ontological-Hysteric Theatre, New York City
New York Times (Friday, 4 March 1977)
© The New York Times

der returned to the city to work as a sound and lighting technician for Richard Foreman's Ontological-Hysteric Theatre production *Book of Splendors: Part Two*, during which he met his partner, John Erdman, a veteran performer in conceptual film, video, and theater productions (fig. 4). Schneider enrolled at the Pratt Institute in 1978 and earned his M.F.A. degree there in 1979.[12] It was at Erdman's suggestion that in 1977 he approached organizers of Artists Space to mount a performance called *Naming*, a work he had presented in South Africa. It involved his inscribing a circle in the corner of the gallery in which he stood and disrobed, after which he interacted with members of the audience by calling for and singing back their names. At Artists Space the performance was accompanied by an exhibition of tangentially related material, including Schneider's 1975 fragmented portraits and a group of his more recent Polaroid instant SX-70 photographs (see plates 3–5), illustrating how variable lighting conditions and long and double exposures significantly distort the portrait photograph. Schneider's keen interest in the effects of light, montage, and sequence, coupled with his engagement in autobiographical conceptual performance, led him to also explore independent filmmaking in the late 1970s and early 1980s.

Of the three short experimental films Schneider made at this time, *Salters Cottages* (1981) achieved the greatest notoriety, and it was screened at the Collective for Living Cinema and the Millennium in Manhattan as well as the Arsenal in Berlin, the Metropolis in Hamburg, and The Funnel in Toronto.[13] Influenced in part by such classic avant-garde films as Maya Deren's surrealist rumination *Meshes of the Afternoon* (1943) and Jean Genet's exploration of male eroticism *Un Chant d'amour* (1950), Schneider scrutinized the theme of seduction with a decidedly ironic edge. He set the film in summer at an oceanside retreat where four characters—a loner played by Erdman, a cruiser played by the photographer Peter Hujar (fig. 5), and a couple played by the painters Suzanne Joelsen and Gary Stephan—pursue one another in vain. In a witty, self-referential gesture, Schneider directs the narcissistic loner to photograph himself

compulsively throughout the film (fig. 6). Claus-Wilhelm Klinker, a German critic, aptly observed that in *Salters Cottages*, "Schneider places the suspense in the approaches to seduction. All the participants are still caught up in the mesh of their customary social relationships and are on the verge of being shaken by a new erotic attraction."[14] The reviewer Tony Whitfield noted Schneider's syntactical innovations, commenting that the "reevaluation of narrative order is the subversive base of Schneider's films and therein lies their promise."[15] Unfortunately, despite the critical success of his early shorts, Schneider was unable to raise the funds he needed to pursue a career as an independent filmmaker. He has not made a film since *Salters Cottages*, although aspects of what he identifies as film techniques and aesthetics — certain qualities of scale, space, light, and montage, as well as approaches to durational image making and the moving point of view — continue to inform his mature work in still photography.

Schneider began the *Entomologicals* series when he had been at an impasse in his art making for more than five years, since the production of *Salters Cottages*. In the intervening years, to earn a living, he became a master printer of other artists' photographs. Through a fortunate turn of events in 1982–83, he succeeded Gert Sander as Lisette Model's printer. At the time, Schneider said, "I knew this would be my one opportunity to learn from a great master and I was right."[16] This experience honed his technical skills, and his clientele subsequently expanded to include such prominent and diverse artists as Richard Avedon, Matthew Barney, James Casebere, Nan Goldin, Peter Hujar, Mary Ellen Mark, Irving Penn, Gilles Peress, David Wojnarowicz, and Louise Dahl Wolfe. He also printed for Madonna's *SEX* book and Brian Lanker's *I Dream a World* exhibition. When printing other photographers' work, Schneider subsumed his own vision to "catalyze their aesthetic."[17] Although this practice intensified his fixation with authorship and identity, the business, along with intermittent teaching commitments at the International Center for Photography, the School for Visual Arts, Cooper Union, and the Maine Photo-

graphic Workshop, became all-consuming, leaving him without the time and physical resources to focus on his own creative enterprises. "I became a 'Sunday painter,'" Schneider said, "and I hated what I was producing."[18]

The *Entomologicals* negatives were the conduit through which Schneider reinvented himself as an artist and propelled his work in a new direction. He found that in the darkroom he could invest the anonymous raw material the negatives provided with an acutely personal interpretation. He compared himself to a musician "playing a score one hundred years later."[19] The *Entomologicals* also marked an essential shift in how Schneider saw the role of photography in his art making. No longer would he use photography solely as a means to document his conceptual performance. Henceforth Schneider would conceive of actions before the camera and, perhaps even more important, in the darkroom, with the specific intention of creating photographs as art objects.

Subverting the Pose

Taken at face value, Schneider's interest in the representation of nineteenth-century negatives might have appeared in sympathy with a widespread tendency by so-called postmodern artists of the 1980s to appropriate all manner of visual and verbal culture in their work. But whereas practitioners of postmodern photography commonly borrowed cliché-laden imagery and text to call into question the very notion of authorship and to expose what they viewed as the determinism behind the illusion of individuality, Schneider used found objects to probe the markers of his identity and assert an extreme form of authorship. "I was not trying to be reactionary or make a political statement," he said, "but all the art I was seeing was about appropriation. I reacted strongly to [it] as a kind of materialism to make more stuff. I was not interested in making more stuff. I was interested in making pieces that were invested with a private authenticity."[20] For inspiration Schneider looked to an array of early photographic types and techniques, from analytical uses of the medium in science to spirit photographs, from the portraits of Julia Margaret Cameron to the arresting botanicals of Charles Hippolyte Aubry.[21] At a time when many artists were using photography to play out the postmodern endgame, Schneider sought to reinvigorate the medium by surveying afresh disregarded aspects of its process and taxonomy.

In a procedure he compared to archaeological exploration, Schneider salvaged thousands of nineteenth-century negatives in the late 1980s. Among them were diminutive unidentified collodion glass plates with half-length seated portraits of primly dressed young women, which he found at a flea market on 26th Street in Manhattan in 1989 (fig. 7).[22] As he had two years earlier with the *Entomologicals*, Schneider made greatly enlarged $37\frac{1}{2}$-by- $28\frac{1}{16}$-inch gelatin silver prints from the small portrait negatives. Here, however, he choreographed the display as an installation of nine pictures hung several inches apart in a single row (fig. 8); the number of pictures was sufficient to subvert the common inclination to interpret the series nostalgically or to project a narrative onto it. Schneider selected the negatives for this piece by the uniformity of their tonal range and the consistency of the poses (see plate 6). "There is a specific photographer's studio formula evident in each portrait," Schneider observed. "The women were told how to dress and were placed at a similar distance from the camera and in a similar light. The photographer rendered a good likeness considering the extended length of exposure which was necessary."[23] In his contemporary interpretation of the nineteenth-century portraits as life-size prints, Schneider generates an effective tension between the regimentation of the pose and the astonishing vitality of the sitters.

Schneider titled the installation of nineteenth-century women *Carte de Visite*, a reference to the 4-by- $2\frac{1}{2}$-inch visiting-card portrait photographs that were widely exchanged and collected in Europe and America in the 1860s and 1870s. Although the negatives that Schneider procured were not made with the multilens camera commonly used to mass-produce cartes-de-visite, they are of a similar size and date.

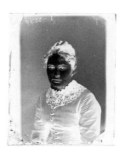

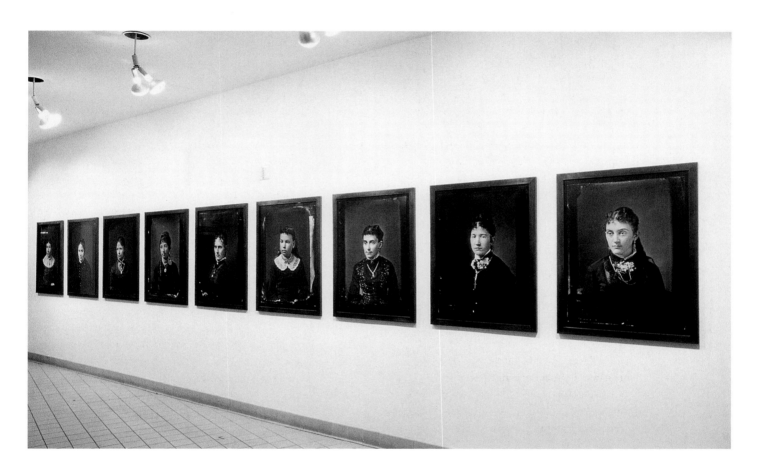

FIG 7
Unidentified photographer
Untitled (portrait of a woman), c. 1870
Source negative for *Carte de Visite*
Collodion wet-plate glass negative
4 1/8 x 3 1/4 inches (10.5 x 8.3 cm)
Collection of Gary Schneider

FIG 8
Carte de Visite, 1990 (as installed at The Cooper Union,
New York City, in 1996)
9 gelatin silver prints
37 1/2 x 28 1/16 inches (95.3 x 71.2 cm) each

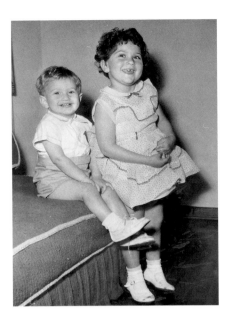

FIG 9
Unidentified photographer
*Untitled (portrait of the artist as a toddler
with his sister Lesley)*, c. 1956
Gelatin silver print
6 x 4 ¼ inches (15.2 x 10.8 cm)

Regardless of its accuracy, Schneider's title appropriately evokes the milieu from which the negatives derive, and it contains a bit of Duchamp-like wordplay as well. Enlarged to life size, the *Carte de Visite* prints convey the sensation of visiting with these long-departed souls. In Schneider's interpretation of the negatives, the women appear disarmingly self-aware, as if engaged in thought or on the verge of conversation. "These portraits seen in a large format unveil a previously undetectable exposure of the subject," he said. "They're totally unveiled; they are presenting themselves." Schneider ascribes this startling openness, which he resuscitated and embellished in the process of printing, to the duration of the original exposure and the sitters' relative unfamiliarity with the act of being photographed.[24] Captivated by the unguarded look of these and other nineteenth-century subjects, Schneider explored ways to undermine the tendency of contemporary sitters, even young children, to assume a contrived expression for the camera (fig. 9).

Toward this end, Schneider began to make long-exposure portraits with a large-format (8-by-10-inch) view camera in 1988. "I don't believe that the face can really show us much on the surface of it," he explained. "We know how to project at the camera, so I found another way to make a portrait that would break through the camera face."[25] Schneider found an essential model in Julia Margaret Cameron's unorthodox search for the essence of her subjects by making closely framed portraits with exposures lasting up to eight minutes (fig. 10).[26] He greatly exaggerates her technique, expanding the length of his exposures to more than an hour for each portrait. Rather than clamping his sitters in place to keep them still, as was the practice in the nineteenth century, Schneider positions his subjects on pads and pillows on the floor of his studio, and has them look up at a camera suspended a few feet above. After adjusting the framing and focus of the portrait on the camera's ground glass, Schneider turns off the studio lights, opens the aperture, and in the pitch dark moves to within a few inches of the subject to begin the painstaking process of illuminating the face segment by segment

FIG 10
Julia Margaret Cameron
Florence Fisher, September 1872
Albumen silver print
14 1/8 x 11 7/8 inches (35.9 x 27.6 cm)
Smith College Museum of Art, Northampton, Mass.
Purchased 1982

with a small flashlight — an adaptation of a standard commercial technique for photographing still lifes that he learned from Peter Hujar.[27]

During the long exposure, Schneider and his subject participate in an improvisational performance before the camera's lens, enacted within guidelines established by the artist. The photographer composes the scene, directs the movement of the light, and controls the exposure, while the subject — voluntarily and involuntarily — engages in and resists the process. The long exposure is a "way to have something else occur inside of that performance — my performance and the subject's performance," Schneider explains. "Something that is totally unexpected and something that, because of the time involved, I as the artist couldn't impose."[28] It is an extremely personal process, related in its intimate collaboration and close observation to the fragmented portraits he made as an art student. Schneider first experimented with the long-exposure technique to make portraits of his perennial muse, John Erdman. In a group of early attempts, Schneider worked out what the method could yield, creating shadowy expressionist images such as the menacing *Hand*, 1989 (fig. 11), and somnambulist *John with His Eyes Closed*, 1992 (see plate 11). In *Double John*, 1989, the depiction of Erdman simultaneously observed and observing is reminiscent of situations Schneider scripted in his films (fig. 12). *Double John* also illustrates the artist's reappraisal of in-camera montage, a technique he explored in his SX-70 portraits of 1976–77.

Combining long- and double-exposure techniques, the portrait of John and doppelganger also relates directly to Schneider's *Botanicals*, begun the same year. For inspiration Schneider once again looked to the past, to what he interpreted as the shared vocabulary of empirical evidence heavily inflected by the hand of an author, which he found in pre-photographic illustrations of botanical specimens and in floral photographs by the nineteenth-century industrial designer Charles Hippolyte Aubry (fig. 13). Schneider became fascinated with the relativism of what is presented as objective information in the visual arts and in science: "I'm always interested in what we

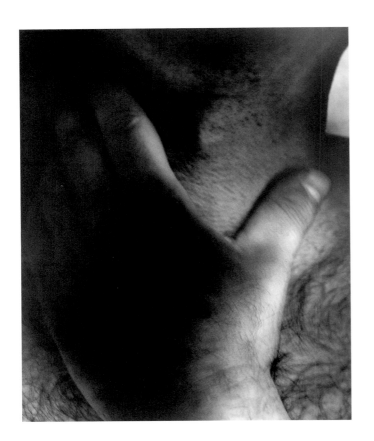

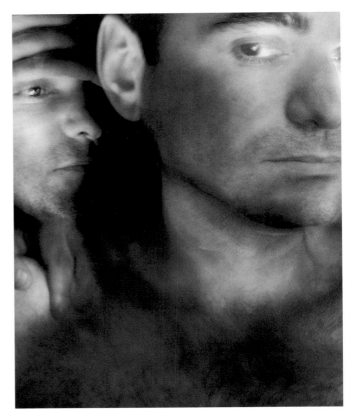

FIG 11
Hand, 1989
Gelatin silver print
36 x 29 inches (91.4 x 73.7 cm)

FIG 12
Double John, 1989
Platinum/palladium print
10 x 8 inches (25.4 x 20.3 cm)

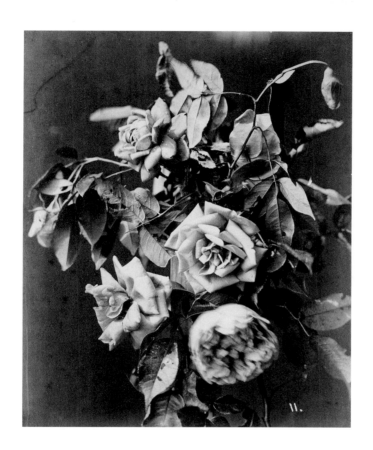

FIG 13
Charles Hippolyte Aubry
Roses, c. 1860
Albumen silver print
11 1/2 x 9 inches (29.2 x 22.9 cm)
Collection of John Erdman and Gary Schneider

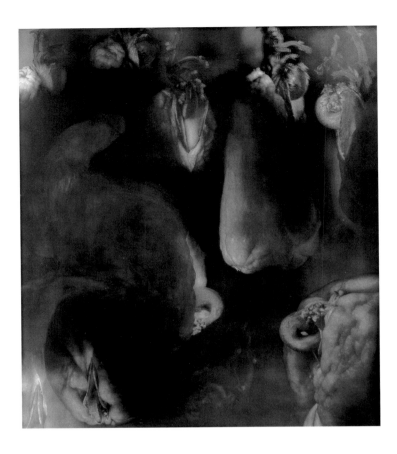

currently believe is fact and the evolution of fact into what we now know is fiction."[29] He searched for a group of anonymous scientific nineteenth-century negatives of plant forms with the intention of reworking them in a contemporary context, as he had with the *Entomologicals* and *Carte de Visite* negatives. When that effort proved unsuccessful, he determined to make his own botanical studies. Each of the *Botanicals* took months to create and is the product of multiple long-exposure sessions during which Schneider returned to the same specimen in various phases of growth or decay, making selected exposures by illuminating the objects with a beam of light on different areas of a single negative. Schneider likened this process to compressing onto a single sheet of film the ubiquitous time-lapse movie documenting the growth of a bean sprout, which enthralled him during biology class. Yet his resulting murky still lifes bear little resemblance to such educational productions; rather, they function allegorically. Schneider even introduces a fragment of John's anatomy into one of them. *Vegetable*, 1993, offers multiple views of an exotic squash rendered as decidedly sexual male and female forms, and enmeshed among them are two exposures of John's genitalia (fig. 14). In this manner Schneider created a hybrid botanical portrait, a fanciful commentary on genetic engineering, and a compelling *vanitas* tableau for the first generation decimated by AIDS.

John, 1989, would serve as the model for a series of durational portraits that Schneider made between 1990 and 1995 (see plate 7). The representation of the subject's emotive face in this early experiment with the long-exposure technique looks as if it is on the verge of dispersal, swelling beyond the edges of the photograph. The scale of the 36-by-29-inch gelatin silver print, many times larger than life, significantly amplifies this effect, as passages of the photograph become contingent and abstract. An alternative realization of the same negative, as a 10-by-8-inch gelatin silver contact print, approximates the actual size of John's face. Schneider intensifies the feeling of anxiety that the portrait engenders by locating our viewpoint uncomfortably close to the surface

of the face. His intention is to have the image envelop the viewer: "I've always wanted you to be inside the photograph rather than looking at it. . . . My photographs have to be viewed either at two inches, like a daguerreotype, or from across the room."[30] The journalist Alan King observed that Schneider's portraits "fill the entire picture plane, and the intensity of his scrutiny borders on violation."[31] Gazing at the quivering, pained countenance in *John*, whatever the scale, the viewer is implicated in a transgression of the subject's private realm.

Writing for *Artforum* in 1995, Lauren Sedofsky speculated about the visual instability of Schneider's long-exposure portraits: "Their imperceptible bit-by-bit montage touches on the problematic character of seeing—the eye's fleeting adherence to fragments regulated by some conceptual integrity—and pushes it past a critical point."[32] In presenting portraits in which the sitters' corporeality appears so conditional, Schneider endeavors, he said, to "find something that's real" about the identity of his subject unencumbered by physical likeness.[33] "We could never see Helen as she appears in Schneider's luminescent black-and-white images of her close-up face," the critic Michael Weinstein cautioned, "because her expression is a composite of the different nuances of emotion that she displayed as she sat for a 30-minute exposure" (see plate 15).[34] To be sure, most of Schneider's long-exposure portraits seem to deny the possibility of a surrogate in the real world. In *Shirley*, 1991, for example, the preternaturally metallic face advances, seemingly detached from the shoulders (see plate 10); *Peyton*, 1994, appears to be a phantom, her bloated countenance irradiated from within (see plate 14); and in *Anya*, 1994, the visage mutates, seeming to dissolve and reassemble before our eyes (see plate 16). What manner of portraiture could be further removed from the prosaic stance that the artist's parents assume in a typical family studio photograph (fig. 15) than Schneider's phantasmagoric durational portraits of them? *Mirriam* and *Reuben*, both from 1993, transmute their subjects into otherworldly apparitions (see plates 12, 13). Indeed, Schneider's long-exposure portraits are sympathetic in technique

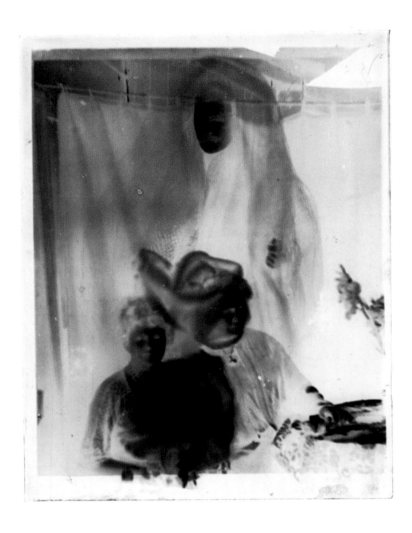

FIG 16
Ada Emma Deane
Untitled (spirit negative), October 13, 1925
Gelatin silver dry-glass plate
4 1/4 x 3 1/4 inches (10.8 x 8.3 cm)
Collection of Gary Schneider

if not intention to so-called spirit photographs, which supposedly registered the ghostly likeness or ectoplasm of the deceased. So similar was the approach that the artist acquired a significant collection of 1920s spirit negatives by the British photographer and spiritual medium Ada Emma Deane in 1991 (fig. 16). He intended to "re-create them" as he had the source negatives for his *Entomologicals* series and *Carte de Visite* installation, but the nature of the material thwarted his efforts. "No matter what I did, they still looked too fake to me," Schneider said. "They just belong so much to their particular time, they don't translate into a contemporary context at all."[35]

Ultimately, Schneider views his durational portraits as an open structure within which an experience may occur, and he engages in this intense process only with people he knows well — his companion, family members, and friends. "When I'm working with someone's face that I really know, what I'm doing to it is so extreme," he said. "I ask myself, is it really them still or is it just all me? I want to believe that it is the accumulation of the secretion of all the expressions that they were making during the exposure — what they were thinking, what they were feeling or what they were projecting. But, of course, there is so much interpretation going on in the camera and in the printing."[36] Schneider's virtuoso ability to modulate the portrait in the darkroom is particularly evident in *Heinz*, 1995, an installation of four 39-by-29-inch photographs stacked two over two (see plate 18). To create this piece Schneider made enlarged prints from each quarter of a single long-exposure portrait negative (fig. 17), repeating a portion of the dissected face along the horizontal and vertical axes. The kinetic composition that results from the partial doubling of Heinz's features, most prominently his eyes, is further exaggerated because the individual panels of the composite portrait are mounted a few inches apart. Moreover, Schneider prints the two sets of eyes so differently in the top and bottom panels that they seem to emit perceptibly dissimilar emotions. It is physiologically impossible for the viewer to get a fix on *Heinz*, to read the portrait in a traditional sense as the coherent topogra-

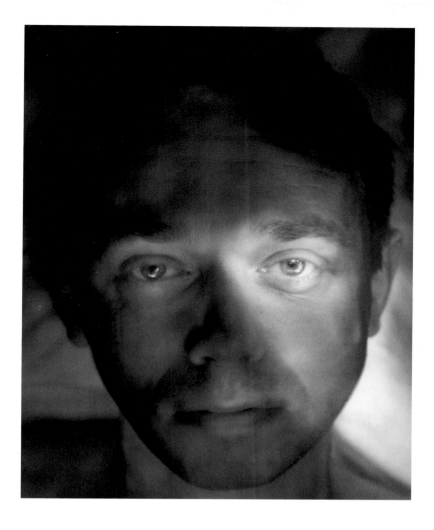

FIG 17
Heinz, 1995
Gelatin silver print
10 x 8 inches (25.4 x 20.3 cm)

phy of an arrested face. Rather, the image of Heinz flickers like the projection of a film stuck between two frames.

Cinematic Space

In his essay "Performance in Photography: Gary Schneider's Photographs," Curtis L. Carter maintains that "by employing multiple sittings over hours or even days, [Schneider] brings to the still photograph some of the qualities of live performance where the development of a character or an action involves the duration of time."[37] To be sure, in its long-exposure technique, serial format, shifting point of view, and conceptual intention, Schneider's work abounds with the evidence of his earlier involvement in performance art and filmmaking, when, he said, he "worked with photography . . . as a script . . . as a part of my process of discovery."[38] His still photographs repudiate the convention of the instantaneous image, and he likens the unique process of exposing and printing them to editing film—"additive and subtractive at the same time."[39] In the mid-1990s Schneider began to create mural-size installations such as *Heinz* and *John in Sixteen Parts*, 1996, to inject cinematic scale into his portraits (see plate 19). As with the films he made early in his career, the artist intends viewers to become enveloped by these works, to suspend disbelief and enter the spaces he invents. These installations reflect as well Schneider's reevaluation of the ways in which multiple photographs can constitute a single work, a format he had experimented with on a much more modest scale in the fragmented portraits he made twenty years earlier.

For all its connections to his durational portrait series, *John in Sixteen Parts* represents a stunning advance in the complexity and scale of Schneider's photographic installations. He determined the conceptual basis of this sixteen-panel portrait of Erdman from the ontology of the medium—four edges to a sheet of film and four sides squared forms the box of a view camera. In this manner Schneider sought to establish a relation between medium and subject matter, process and meaning. *John in Sixteen Parts* consists of prints made from four negatives; each nega-

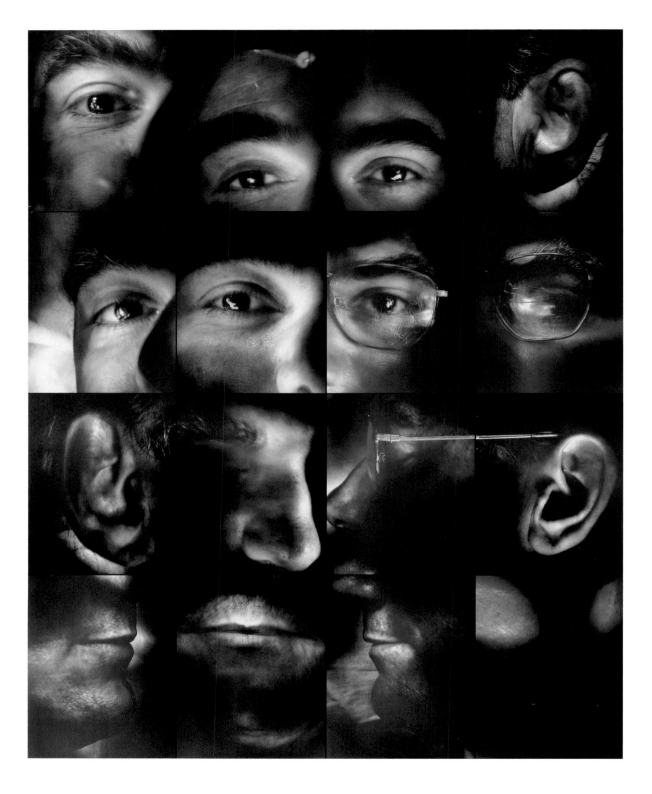

tive was exposed four times, for a total of sixteen exposures. Instead of dividing a single long-exposure portrait negative to create a multipanel portrait during the printing process, as he had with *Heinz*, Schneider fragmented the portrait in the camera by isolating different segments of John's face for each durational exposure. He predetermined the composition of the finished piece to create a narrative relationship among the four composite negatives, and conceived it to be installed either as four rows of four panels (fig. 18) or two rows of eight panels (see plate 19). In the former, each quadrant of four panels represents the information on one negative; in the latter, the four-panel clusters are arranged side-by-side from left to right. Of the two arrangements, Schneider favors the more abstract linear presentation, which the critic Vince Aletti fittingly described as a portrait "as cerebral as it is physical," making "Cubism feel stodgy."[40]

Reduced to its most essential element, *John in Sixteen Parts* is the collective afterimage of sixteen performances that Schneider enacted with John Erdman over the course of several months. The individual panels that compose the portrait present an inventory of features — eyes, mouth, nose, and ears — as a litany of the senses. Yet these components of Erdman's face are viewed disembodied, transformed, and multiplied, as if they were pieces of a jigsaw puzzle gone awry. In his careful observation of discrete organs from different vantage points, Schneider has applied his method of studying botanical specimens to the human face. As he usually does, for each long exposure Schneider positioned his subject before the large-format camera and then navigated around him in the dark, selectively revealing aspects of Erdman's visage with a directed light. The resulting photographs are layered with traces of movement in time through the effects of the intermittent light and the involuntary shifting of the sitter. To pore over Erdman's features is to engage in a lesson about vision and perception. Schneider slowly builds his description based in part on what Erdman will reveal of himself and in part on how the artist deciphers his subject, but without ever reconstructing Erdman's appearance in a traditional manner. The shallow

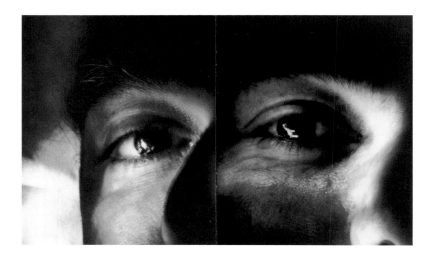

space Schneider creates appears indefinite, but it maintains its own palpable substance. Some features are vivid and recognizable and others remain obscure, as if suspended in a viscous ether. Rather than conveying verisimilitude, Schneider displays traces of Erdman's physiognomy as compressed remnants of his psychology shifting over time.

In 1997 Schneider's galleries published a 10-by-8-inch artist book, offering viewers an intimate version of *John in Sixteen Parts* to take into their hands.[41] There Schneider established the sequence of the images and the relationship between them, using rhythm, repetition, and pause to punctuate the viewer's movement through the portrait. The book begins with seven pages devoted to the shifting attitudes of Erdman's eyes — a single Cyclops-like oculus is followed by two spreads of piercing open eyes, and then a spread in which the eyes are obfuscated by light reflections on the lenses of Erdman's glasses. The pair of right eyes depicted on the first double page are at once undeniably two right eyes and a matched pair, a normal face (fig. 19). In other words, in spite of evidence to the contrary, viewers reconstruct the visual schema Schneider presents to accommodate their expectation of what they should see. In this pictorial narrative, logic succumbs to intuition, conditioning, and desire. It is exactly this balancing act between observation and instinct that activates Schneider's work.

With *John in Sixteen Parts* Schneider pushed the durational portrait to the medium's limit; it was not until 1999 that he returned to the technique to initiate a new series of large-scale color portraits, chromogenic prints made from digitally modified transparencies.[42] As a young artist Schneider had experimented with the unnatural color the Polaroid SX-70 process could produce when manipulated, and he has always heavily toned his gelatin silver prints, saturating them with distinct tints. Even so, his recent decision to push the boundaries of color technology in photography represents a startling departure. As he had for *John in Sixteen Parts*, Schneider predetermined for the new color portraits the guidelines of what would occur before the camera. In this body

FIG 19
John in Sixteen Parts (page spread), 1997
Artist book
Photomechanical reproduction
10 x 8 inches (25.4 x 20.3 cm) (closed)

of work, however, he endeavored to subvert his authorship by foregrounding the unique experience of the sitter. To achieve this result Schneider regimented the order in which he photographed each part of the subject's face, reduced the exposure time to ten minutes, and eliminated extraneous references by floating the seemingly disembodied heads on a black ground. He modeled the series on *Carte de Visite* inasmuch as he enforced his own rigid studio standard to emphasize what he saw as the "amazing differences between [the subjects]."[43] At first glance, the color works appear to be less distorted depictions than Schneider's earlier durational portraits. Still, the color mutations caused by the length of the exposure and the size of the prints, where the head measures nearly five feet in height, conspire to abstract the face (fig. 20). In fact, Schneider deliberately enlarges the color portraits to the point where artifacts of the process begin to become visible. When we stand before these oversize heads, passages of color and form open up as if they were vast stretches of landscape, as exemplified by the molten terrain of *Helen's* cheeks, the double peak of *Vince's* nose, and the spectral topography of *John's* forehead (see plates 21, 23, 20). The viewer becomes entranced by the cinematic expanses held in the interstices of these epic portraits, and by the illusion that the pulsating heads alternately advance and recede in space.

Drawing from Biology

Schneider's passion for close scrutiny derives in part from his lifelong curiosity about science. "The reason why I've been fascinated with scientific language or how scientists make images is that I loved biology class," he reflected. "It was the only class in school in which I was really happy, making those diagrams and drawings."[44] References to biology abound in Schneider's work, from the nineteenth-century scientific negatives he appropriated for *Entomologicals* to his collaboration with contemporary scientists on his critically acclaimed installation *Genetic Self-Portrait*, 1997–98. In addition to reworking historical and modern scientific negatives for his own creative purposes, Schneider has printed directly from biolog-

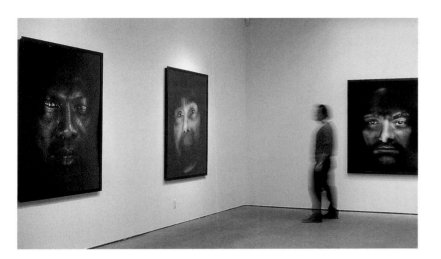

FIG 20
Installation of *Gary Schneider "Portraits"*
Julie Saul Gallery, New York, 28 February–19 April 2003

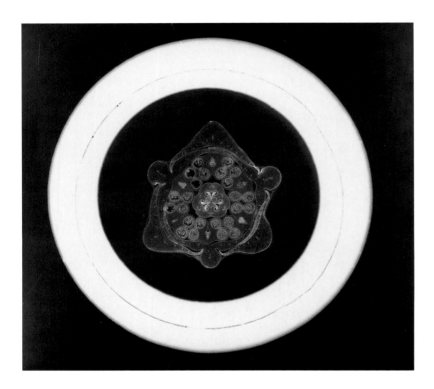

ical specimens, using his enlarger as a microscope.[45] The first instance of this practice occurred in 1992, when he made large-scale photographic prints from old-fashioned glass microscope slides that preserved tiny insects and cross sections of plants (fig. 21). The following year Schneider propelled this method to another level when he imprinted two sheet-film negatives with the sweat and heat from his left hand, thereby making photograms—or thermohydrograms, as the images have been more accurately labeled —that both contain and record aspects of his biological identity.[46] The hand-imprinted negatives reveal quantifiable information about Schneider. We can observe his gestures, trace the unique pattern of his fingerprints, note the proportions of his fingers and measure the amount of heat and liquid his body emitted as the negatives were made. Here Schneider is at once the source of the specimen, the scientist conducting the experiment, and the artist interpreting empirical information.

Schneider spent hours pressing his palm against unexposed negative film in his first attempts to register biological information on film. After many failures, he also experimented with wetting his hand and flashing the negative with light. Eventually he succeeded in producing two markedly different imprinted negatives of his left hand—an austere sweat-hand imprint showing the fingers splayed, and an expressionist wet-hand imprint with the fingers together. In printing photographs from the hand negatives, Schneider aimed to make a "generic portrait type"—an utterly malleable image that referenced the history of such human mark making, from prehistoric cave painting to religious icons to the modern art of Moholy-Nagy, Jasper Johns, and beyond.[47] Writing for *Artnews*, the critic Richard B. Woodward compared one of Schneider's images made from the negative imprinted with a wet hand to the images found in the "caves of Lascaux—dim, ancestral recesses of history where handprints are the earliest record of artistic presence." Peter von Ziegesar suggested in a 1995 *Art in America* review of an exhibition of Schneider's handprints at the P.P.O.W. Gallery in New York that they "resemble giant X-rays" and that "one

gets an eerie sense of apparitions evoked, as in a turn-of-the-century séance."[48] The artist courts this range of primal, metaphysical, historical, and scientific readings of his work, making layered and varied prints, which through darkroom alchemy appear to render substance. The four prints in *Meditations*, 1993, an installation of four enlarged photographs, for example, are all made from the same negative, yet each is unique, edited and toned to create subtle relationships among the images and varying responses in the viewer (see plate 24).

For Schneider, *Meditations* functioned as a self-portrait, an emotional "tone poem," an outlet for personal grief, and a rumination on mortality during a time when he lost many of his friends to AIDS. In fact, he felt that the piece was so personal and self-indulgent that he held it back from public display until 1996.[49] Yet his ability to invoke diverse sensibilities by variously resolving the handprints led Schneider to make different versions of them as memorial portraits to specific individuals between 1993 and 1994. *After Peter Winter*, 1993, and *After Ethyl*, 1993, dedicated to the photographer Peter Hujar and performer Ethyl Eichelberger, derive from the same sweathand negative (see plates 25, 26). Schneider's realization of the two prints could not be more different, however. The painfully ethereal *After Ethyl* looks like a latent print made barely visible by some forensic technique, while the brooding *After Peter Winter* implodes with emotional and tonal density. Schneider made a similar range of modifications among the memorial portraits he created from the wet-hand-imprinted negative, as seen in *After Peter Fall*, 1993, and *After Bill*, 1994 (see plates 27, 28). But here the distinction between them results in part from the fact that Schneider made one a negative and the other a positive print from the negative, and in part from the manipulation of each print in the darkroom by editing the light exposure and toning extensively. These photographs were integral to Schneider's mourning process, as he explained: "Because I've dedicated each handprint to a specific person . . . [and] printed it with that person in mind, . . . it . . . becomes inexplicably linked to that particular person. Because each of

these photographs begins with my hand imprint, they also become a kind of memory marriage, a glove for that person to inhabit and my way to punch back." [50]

The last memorial hand portrait Schneider would make, the four-panel mural-size installation *After Mirriam* is dedicated to his mother, who died of lung cancer in 1994 (see plate 29). For this work Schneider used his sweat-imprinted-hand negative, dividing it into four sections and printing each as a distinct image, while repeating some information along the vertical and horizontal axes. It is the same technique he would use a year later for the durational portrait installation *Heinz*. *After Mirriam* is a particularly ethereal elegy. The perimeter of the hand appears haloed, and light seems to be emitted from the center of the palm. "I'm always searching for the sensibility that my works are lit from within," Schneider said. "It was at the point where I could achieve that particular experience with space that I came back to photography, because, of course, film is about that experience of space and light. That's what I loved about film, you're inside of film's space." [51] In *After Mirriam* Schneider's yearning to be transported into the space of the memorial portrait assumes a particularly tender significance. Yet he constructs the installation so that the hand appears to recede into the indistinct ground. He achieves this effect by fragmenting the image, which creates the illusion that the portion of the palm that appears in the upper panels is rendered at a slightly smaller scale than in lower panels.

In 1995 Schneider revisited his hand-imprinted negatives for the last time, creating a variant of *Meditations* titled *Four Seasons*, in which each of the four hand prints is divided into four 24-by-20-inch panels, for a total of sixteen elements (fig. 22). In spite of its similarities to *Meditations*, *Four Seasons* is a more cerebral and less emotional piece. It opened up a new direction for the handprints beyond their original commemorative purpose. Spurred by the suggestion of a hand surgeon, a cousin of Erdman's who visited the exhibition of the memorial portraits at P.P.O.W. in 1995, Schneider determined to create imprint negatives using others' hands, and he pro-

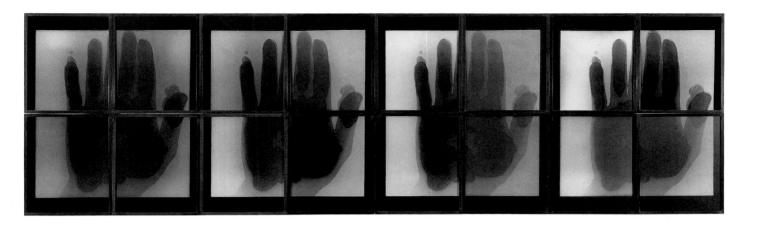

FIG 22
Four Seasons, 1995
16 gelatin silver prints
24 x 20 inches (61 x 50.8 cm) each
Collection of C. B. Heckett

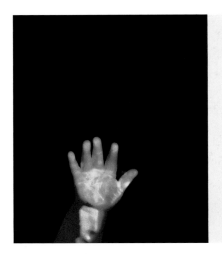

HANDBOOK

GARY SCHNEIDER

STORIES BY LYNNE TILLMAN

FIG 23
Handbook (title page, maquette), 1998
Artist book
Photomechanical reproduction
10 x 8 inches (25.4 x 20.3 cm) (closed)

ceeded to experiment with a variety of photographic materials and techniques to accelerate the darkroom process. The technique he evolved takes only a few minutes and consistently produces shimmering, luminous handprints against a velvety black ground. Imagining himself a scientist, Schneider began collecting handprint samples, as if they were biological specimens, from his family and friends. The first successful piece he completed using the new technique was of the hand surgeon and his family, the *Barron Family Portrait (Alton, Carrie; Chloe)*, 1996, composed of three 10-by-8-inch gelatin silver contact prints (see plate 30). Schneider found striking the way the couple, independent of each other, placed their hands so similarly on the unexposed negative and how their heat and sweat patterns correspond as well; in contrast, the handprint of the couple's biological child bears no resemblance.

Normally a strict editor of his own work, Schneider considers the hand portraits the "only body of work that I want to make more and more, because each one is so different, even though I use exactly the same process."[52] Originally the family handprints were to be issued as an artist book, naturally titled *Handbook*. In his maquette for *Handbook*, 1998, Schneider interspersed groupings of individuals, couples, and families with short stories that his friend Lynne Tillman wrote, inspired by the work (fig. 23).[53] A delay in the publication of *Handbook* has led Schneider to create alternative expressions of the project, such as installations and the small-edition artist publication *The Yezerski Family Portrait*, 2001, a handprint portrait illustrating three generations of the family of Schneider's Boston dealer and friend, Howard Yezerski (fig. 24). The publication comprises a set of seven varnished tritone reproductions of the handprints together with a diagram of the family tree set into an elegant four-flap black folder. The format mimics the folders that commercial portrait studios provide their patrons to protect more traditional versions of the family portrait.

Schneider's most ambitious family hand portrait to date represents the four generations of his own clan in a seventeen-panel installation mounted in the

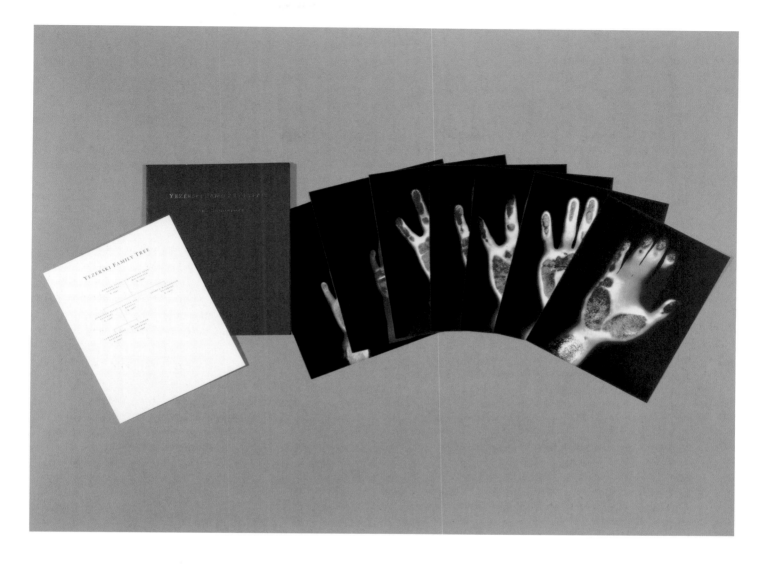

FIG 24
The Yezerski Family Portrait, 2001
Artist book, photomechanical reproduction
10 x 8 inches (25.4 x 20.3 cm) (closed)

form of a family tree across four horizontal rows. Schneider has written eloquently about *Schneider Family Portrait (Reuben, Rhona; Lesley, Eric, Gary, John, Marlene, William, Adrienne, Roy; Nicole, Brett, Jaime, Erica, Gavin, Carly; Alexa at Five Months)*, 2002 (see plate 32), connecting the central issues it raises for him to those he explored in *Genetic Self-Portrait* a few years earlier:

The relationships between my father and Rhona (not my mother), and my three sisters and their spouses are fascinating. Like many other family handprint portraits I have made, the formal similarities and differences seem to be very clear. Why do we choose our partner? What do we inherit? There seems to be a similar biology of my handprint and that of my two brothers-in-law, Eric and William as well as my sister Adrienne (not married to either of them). The similarity of gesture between certain spouses; my father and his wife, my eldest sister Lesley and her husband Eric, my youngest sister Adrienne and her husband Roy and the difference between my hand and my partner John's. The difference physically between my middle sister Marlene and her husband William. See how their gesture, how they lay their hand down, is similar. I am reading excessively into these images but this kind of questioning does begin to occur and I can continue to speculate with the next generation and between generations. More than any other work I have completed, these portraits make me think more specifically about privacy and identity. How we choose our family. How those choices may come from touch and heat, through our hands, rather than through sight. Maybe the inherited sense of touch is more primal than our sense of sight. Maybe our sense of sight is too affected by other influences. As the field of genetics grows it must include a different kind of questioning. As it changes, how will the family structure change? How do we make our choices? As our menu of making choices changes, how will this change the nature of family?[54]

A Contract About Privacy

In 1996 a philanthropist invited Schneider to make an artistic response to the Human Genome Project, the formidable initiative coordinated by the Department of Energy and the National Institutes of Health

to identify every gene in human DNA and map its sequence across all forty-six human chromosomes.[55] As daily news headlines attest, the information that genomic scientists have gleaned from this effort is revolutionizing our understanding of evolution, race, health, energy, and the environment, but it has also caused considerable controversy about ethical issues, including genetic privacy. Given his fascination with biology, Schneider was more than intrigued by the prospect and quickly focused his interest on the Human Genome Project's promise as a powerful diagnostic tool for hereditary diseases, such as the form of lung cancer that had recently claimed his mother's life. He determined to make a "diagnostic self-portrait, where I could harvest images from my own body," that "was all about fact identity or what we believe is fact."[56] During an eighteen-month period in 1997 and 1998, Schneider collaborated intensively with a group of scientists at Columbia-Presbyterian Medical Center in New York to create images of biological specimens taken from his body, using principally forms of photo microscopy. Schneider approached the analytic pictures the scientists provided as source material to be manipulated in the darkroom in his usual manner. The epic fourteen-image (fifty-five panel) installation *Genetic Self-Portrait*, 1997–98, that Schneider produced remains his most complex, mysterious, and innovative self-portrait (see plates 33–44).

While making *Genetic Self-Portrait*, Schneider, like the colonial of his imagination, lived inside a microscope, examining the evidence of his own biological identity. He was awed by what he saw. "I always had assumed that chromosomes were some kind of digitally produced rendering, that they could not actually be seen," he said. "It was just too amazing."[57] In addition to his chromosomes, Schneider's *Genetic Self-Portrait* displays greatly magnified representations of his tumor suppressor gene, buccal mucosa cell with nucleus and mitochondria, DNA sequences, sperm, and hair. The source photographs for all of these were made by scientists using such advanced imaging devices as an auto radiogram, fluorescent-light microscope, light microscope, transmission elec-

tron microscope, nanoscope atomic force microscope, and scanning electron microscope. The installation also includes photographs enlarged from negatives documenting Schneider's irises and retinas with a Fundus camera, a dental panoramic radiograph, and a dried blood sample on a glass microscope slide. As the project evolved he became concerned that the specimen photographs failed to fully represent the range of his personal responses to the Human Genome Project. To provide a counterpoint to the clinical samples, Schneider incorporated a pair of handprint and ear print photographs, enlarged from sweat- and heat-imprinted negatives using the technique he had developed in 1996 (see plate 33). "It was with the addition of the handprints that the portrait moved . . . to an emotional response to the Human Genome Project," Schneider wrote in the catalogue that accompanied the international tour of *Genetic Self-Portrait* in 1999–2000.[58] With this shift in perspective, Schneider also extensively reworked the scientific source images in the darkroom, creating prints that straddle science and art in unexpected ways.

A number of writers, fittingly, have compared the experience of walking through the installation of *Genetic Self-Portrait*, with its ten-foot-tall segment of a buccal mucosa cell and six-foot-long strand of hair, to the science-fiction movie *Fantastic Voyage*, in which miniaturized people traverse the unfamiliar micro-landscape inside the human body (see plates 37, 34). But equally beguiling is the way Schneider's colossal photographs of tiny scientific specimens allude to a host of images from the history of visual culture even as they index forensic evidence. The two images of *Retinas*, 1998, for example, recall early-twentieth-century pictorial landscapes by Edward Steichen, with their tree branches silhouetted before a full moon (see plate 39). *DNA DYZ3/DYZ1*, 1998, is transmuted into a sensual pear-shaped back, reminiscent of Edward Weston's famous anthropomorphic peppers, while *Hair*, 1997, brings to mind Karl Blossfeldt's macro botanical studies (see plates 40, 41). The *Buccal Mucosa Cell in the Oral Cavity to Show a Nucleus and Mitochondria*, 1997 (see plate 37), evokes Chinese landscape painting,

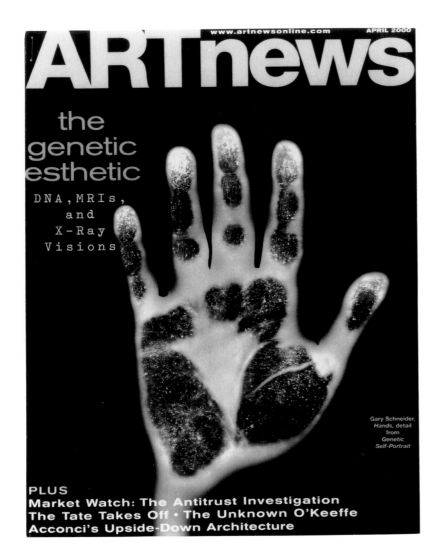

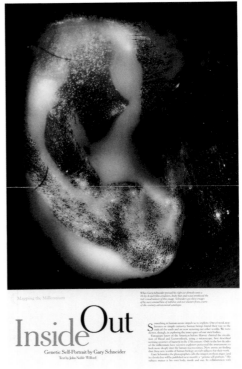

FIG 25
Cover of *Artnews*, April 2000, featuring a detail of *Hands*
from Gary Schneider's *Genetic Self-Portrait*

FIG 26
Page spread from John Noble Wilford's "Inside Out: Genetic
Self-Portrait by Gary Schneider," *New York Times Magazine*,
17 October 1999, 106–7, featuring a detail of *Ears*
© The New York Times

and indeed was inspired by Dong Yuan's tenth-century scroll painting *Riverbank* at New York's Metropolitan Museum of Art. Celestial events can be found in *Hands*, 1997, *Ears*, 1997, and *Irises*, 1997 (plates 42–44). On one level, as Schneider noted, *Genetic Self-Portrait* is "all about the history of image making through a pictorial eye."[59] But it's also about the synthesis and collision of scientific and artistic methods and viewpoints.

Schneider, who for most of his career had worked counter to the prevailing direction in photography, was caught up short by the substantial critical attention conferred on *Genetic Self-Portrait*. He found himself unwittingly leading a trend described by Barbara Pollack in the *Artnews* cover story "On the Edge: The Genetic Esthetic," which prominently featured his work (fig. 25).

Schneider is one of a growing number of artists using cutting-edge medical technology—from x rays and MRIs to DNA diagnostics—as part of their art making practices. Documented in the scientist's lab and transformed in the artist's studio, this kind of work brings a new view of the body to public attention with images that can range from color photographs of chromosomes to video footage of interior organs. Stripping away a person's outside appearance in that way, artists are, in essence, redefining traditional notions of portraiture and questioning what signifies individual identity.[60]

Genetic Self-Portrait was the subject of an eight-page photo essay in the "1000 Years of Mapping the Millennium" issue of the *New York Times Magazine*, which later earned an Alfred Eisenstaedt Award from *Life* magazine as the best essay depicting science or technology in 2000 (fig. 26).[61] The installation has been on perpetual tour since its completion. It has been included in a number of pioneering exhibitions focusing on artists' responses to contemporary science, including *Paradise Now: Picturing the Genetic Revolution*; *Unnatural Science*; and *Out of Sight: Imaging/Imagining Science*, as well as those concerned with portraiture and identity, such as *Under the Skin: Transformations in Contemporary Art* and *Head to Toe: Impressing the Body*.[62] Interest in *Genetic Self-Portrait* extended

beyond the art world as well. The piece has appeared in publications as diverse as *Update: New York Academy of Sciences Magazine* and social forecaster John Naisbitt's *High Tech/High Touch*, which investigates the human response to new technologies.[63]

Naisbitt makes the trenchant point that regardless of the work's pictorial, allegorical, and cultural resonance, from the perspective of the scientist it depicts the ultimate disclosure of Schneider's identity; and he quotes a UCLA scientist's observation that displaying "this [work] is like standing naked raised to the highest power. Not only are you naked at the surface, but you're naked all the way through from the level of the macroscopic down to the level of atoms."[64] In the end, Schneider's obsession with looking at things up close in acts of self-discovery led him to this degree of personal disclosure within the public realm. "What I didn't expect was that . . . I would have such an emotional response to what I was photographing, to the loss of privacy, to the fear of biology," he said. "It's about privacy. These are my most private parts. Everything I've done is about privacy. A portrait is a contract about privacy."[65]

Notes

1 Vincent Katz, "Gary Schneider: An Interview," *Print Collector's Newsletter* 27/1 (March–April 1996), 14.

2 Gary Schneider, typescript of an untitled public lecture, Hood Art Museum, Dartmouth College, Hanover, New Hampshire, on the occasion of the *Surface and Depth* exhibition, 2000.

3 Gary Schneider, conversation with the author, 2002; and Gary Schneider, typescript of an untitled public lecture, College Art Association, New York, 22 February 2000.

4 Gary Schneider, typescript of an untitled lecture, International Center for Photography, New York, 1998.

5 Schneider, conversation with the author, 2002.

6 Schneider felt a special connection with Coplans, whom he described as a "great editor." Schneider and Coplans's niece attended school together and became friends. Schneider, conversation with the author, 2002.

7 Robert Pincus-Witten, "Theater of the Conceptual: Autobiography and Myth," *Artforum* 12/2 (October 1973), 40–46.

8 Ibid. and Robert Pincus-Witten, "Vito Acconci and the Conceptual Performance," *Artforum* 10/8 (April 1972), 47–49.

9 Pincus-Witten, "Theater of the Conceptual" and "Bruce Nauman: Another Kind of Reasoning," *Artforum* 10/6 (February 1972), 33.

10 Schneider, conversation with the author, 2003; Schneider, typescript of an untitled public lecture, Hood Art Museum, Dartmouth College, Hanover, New Hampshire, 2000.

11 Schneider, typescript of an untitled lecture, International Center for Photography, 1998.

12 Erdman had performed for Joan Jonas, Yvonne Rainer, Richard Foreman, Charles Atlas, Heinz Emigholz, and Robert Wilson.

13 Schneider's other two films are his graduate thesis for Pratt Institute, Brooklyn, titled *Peripheral Intercourse*, 1979, 16mm, which received a Hy Goldman Memorial Grant and was exhibited at Millennium, New York, and *Untitled*, 1977, Super-8, undergraduate thesis, Michaelis School of Fine Art, University of Cape Town.

14 Claus-Wilhelm Klinker, "Drei radikale Kurzfilme über Sex-nicht nur für Schwule," *Szone* [Hamburg, Germany], October 1984. Translated by Liam Burke.

15 Tony Whitfield, "Psychological Seduction," *New York Native*, 1982.

16 Gary Schneider, typescript of an untitled lecture, International Center for Photography, 1998.

17 Schneider, conversation with the author, 2002.

18 Schneider, typescript of an untitled lecture, International Center for Photography, New York, 1998.

19 Schneider, conversation with the author, 2002.

20 Ibid.

21 Ibid.

22 Gary Schneider, "Artist's Statement on 'Carte de Visite,'" P.P.O.W., New York, 1991.

23 Ibid.

24 Ibid.; see also Katz, "Gary Schneider: An Interview," 13.

25 Schneider, conversation with the author, 2002.

26 For Cameron's exposure times, see Sylvia Wolf, *Julia Margaret Cameron's Women*, exh. cat. (The Art Institute of Chicago, 1998), 215.

27 Schneider, conversation with the author, 2002.

28 Katz, "Gary Schneider: An Interview," 142.

29 Schneider, conversation with the author, 2002.

30 Gary Schneider quoted in excerpts from "Light Conversation: Seminars with Contemporary Photographers at the Fogg Art Museum," published in *Harvard University Art Museums Review* 6/2–7/1 [special double issue on "Photography and the Art Museums"] (Fall 1997), 14.

31 Alan King, "Photography Can Turn Its Subjects into Icons," *Ottawa Citizen*, 16 June 1995.

32 Lauren Sedofsky, "Gary Schneider's Photographs: Through Glass Darkly," *Artforum* 33/7 (March 1995), 72.

33 Schneider, conversation with the author, 2003.

34 Michael Weinstein, "Schneider Gallery," *Chicago News and Arts Weekly*, 21 December 1995.

35 Schneider, conversation with the author, 2002.

36 Ibid.

37 Curtis L. Carter, "Performance in Photography: Gary Schneider's Photographs," in *Gary Schneider: Recent Photographs*, exh. cat. (Haggerty Museum of Art, Marquette University, Milwaukee, 1997), n.p.

38 Schneider quoted in excerpts from "Light Conversation," 14.

39 Katz, "Gary Schneider: An Interview," 142.

40 Vince Aletti, "Gary Schneider," *Village Voice*, 22–28 October 1997.

41 Gary Schneider, *John in Sixteen Parts* (Worcester, Mass., 1997). The book was published by the artist's dealers (P.P.O.W. Gallery, New York; Howard Yezerski Gallery, Boston; Stephen Daiter Photography, Chicago) in an edition of one thousand copies, of which 210 are cased, signed, and numbered. My interpretation of *John in Sixteen Parts* is adapted from my introductory essay to the artist book "Dancing in the Dark(room): Gary Schneider's *John in Sixteen Parts*." Schneider's artist book was reviewed in Nancy Princenthal, "Artist's Book Beat," *Art on Paper* (January–February 1999), 66.

42 Inspired by Josef Sudek's work, Schneider originally intended to realize the large color heads as pigment prints but was not able to achieve enough control of the process to get the results he envisioned. Similarly, the results of printing the portraits as Cibachromes directly from the transparencies proved too variable. Finally he digitized the transparencies so that he could manipulate the color and contrast in Photoshop before printing the portraits as chromogenic prints using Fuji Crystal Archive paper.

43 Schneider, conversation with the author, 2002.

44 Ibid.

45 Schneider, typescript of an untitled lecture, International Center for Photography, 1998.

46 Lori Pauli, assistant curator of photographs, and John McElhone, conservator at the National Gallery of Canada, coined this descriptive term in Gary Schneider, *Genetic Self-Portrait* (Syracuse, N.Y., 1999), n.p.

47 Schneider, typescript of an untitled public lecture, College Art Association, New York, 22 February 2000.

48 Richard B. Woodward, "Gary Schneider," *Artnews* 97/2 (February 1998), 121; Peter von Ziegesar, "Gary Schneider at P.P.O.W.," *Art in America* 83/10 (October 1995), 122.

49 *Meditations* was exhibited for the first time in 1996 in a solo exhibition of Schneider's work, titled *1993*, at Howard Yezerski Gallery.

50 Schneider, conversation with the author, 2002.

51 Ibid.

52 Ibid.

53 Lynne Tillman published the stories in her anthology of writings inspired by artists, *This Is Not It* (New York, 2002). Schneider's handprint *Chloe* was reproduced in the book.

54 Gary Schneider, typescript of an unpublished artist statement on *Schneider Family Portrait*, 2003.

55 Human Genome Project Information URL: http://www.ornl.gov/hgmis/.

56 Schneider, conversation with the author, 2002.

57 Ibid.

58 Gary Schneider quoted in Gary Schneider, *Genetic Self-Portrait*.

59 Schneider, conversation with the author, 2002.

60 Barbara Pollack, "On the Edge: The Genetic Esthetic," *Artnews* 99/4 (April 2000), 134.

61 John Noble Wilford, "Inside Out: *Genetic Self-Portrait* by Gary Schneider," *New York Times Magazine*, 17 October 1999, 106–13; "The 2000 Alfred Eisenstaedt Awards, Science Essay Winner, Best Essay Depicting Science or Technology," *Life* (Spring 2000), 36–37.

62 Marvin Heiferman and Carole Kismarie, *Paradise Now: Picturing the Genetic Revolution*, Exit Art, New York (2000); Laura Steward Heon, *Unnatural Science: An Exhibition*, MASS MoCA (Spring 2000–Spring 2001); and Karen Sinsheimer, *Out of Sight: Imaging/Imagining Science*, Santa Barbara Museum of Art (11 April–7 June 1998); Christopher Brokhaus, "Gary Schneider," in *Under the Skin: Transformations in Contemporary Art*, Lehmbruck Museum of Art, Duisburg (6 May–17 June 2001); Donna Harkavy and Margaret Mathews-Berenson, *Head to Toe: Impressing the Body*, University Gallery, Fine Arts Center, University of Massachusetts, Amherst (6 November–17 December 1999).

63 *Update: New York Academy of Sciences Magazine* (August–September 2002), cover, 2–5; John Naisbitt, *High Tech/High Touch* (New York, 1999).

64 Harvey Herschman quoted in Naisbitt, *High Tech/High Touch*, 201.

65 Schneider quoted in Guy Trebay, "The View Finders: Four Photographers Keep Up the Image," *Village Voice*, 28 February 2000; and Schneider, conversation with the author, 2002.

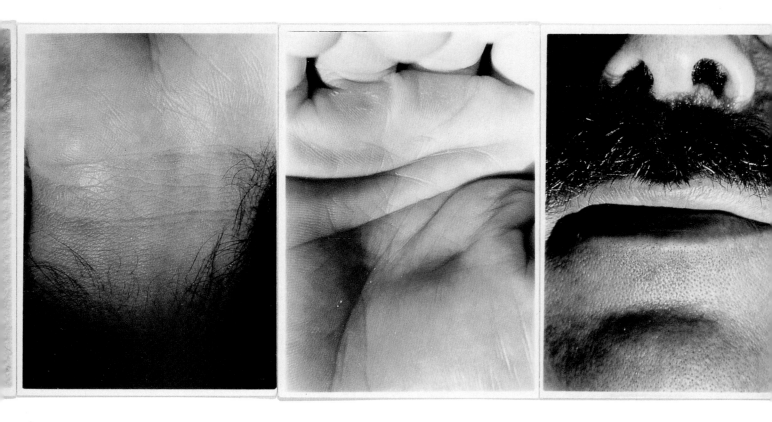

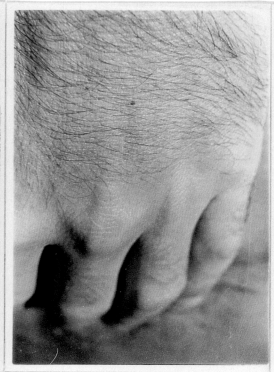

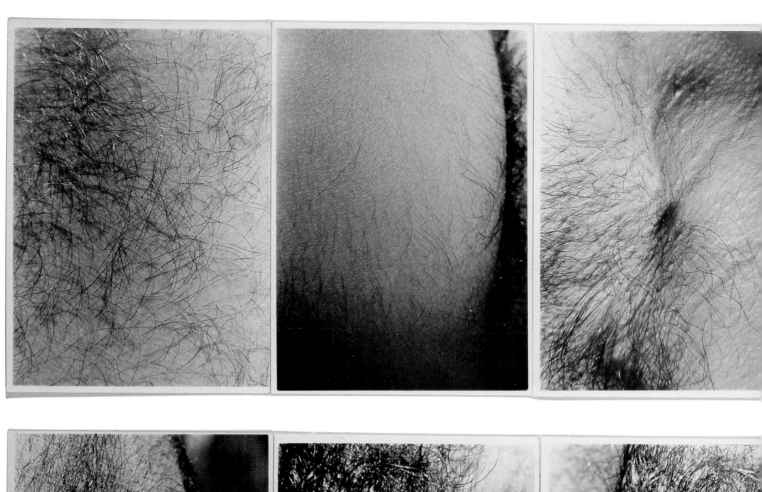

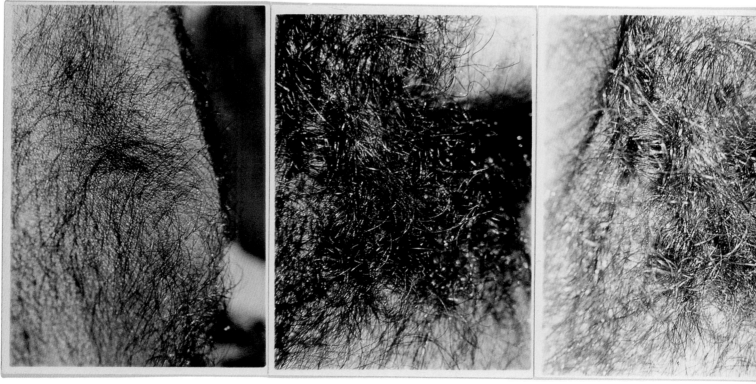

Portrait of Ralph, 1975, 16 gelatin silver prints, 5 ⁹/₁₆ x 3 ¹/₄ inches (14.1 x 9.5 cm) each

Plates

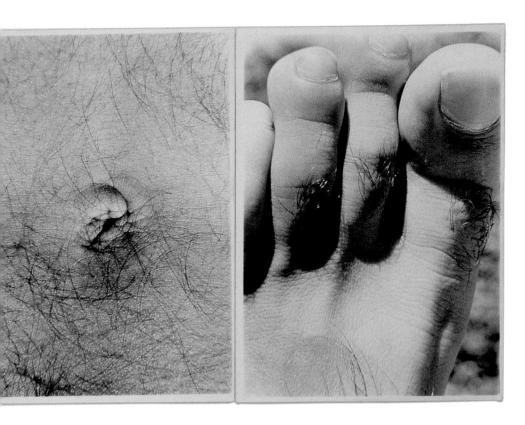

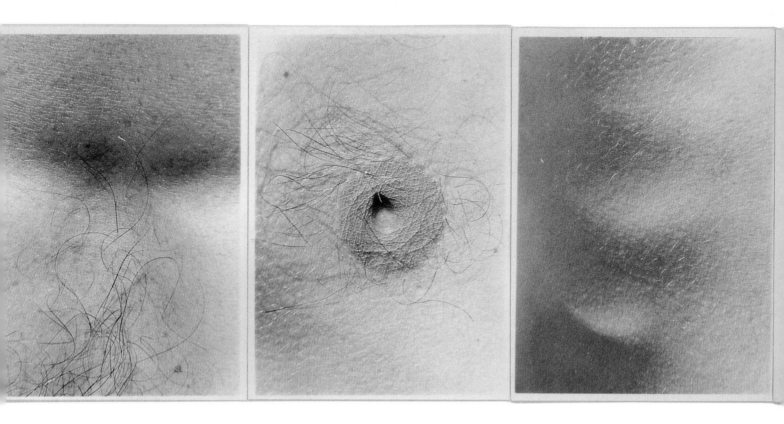

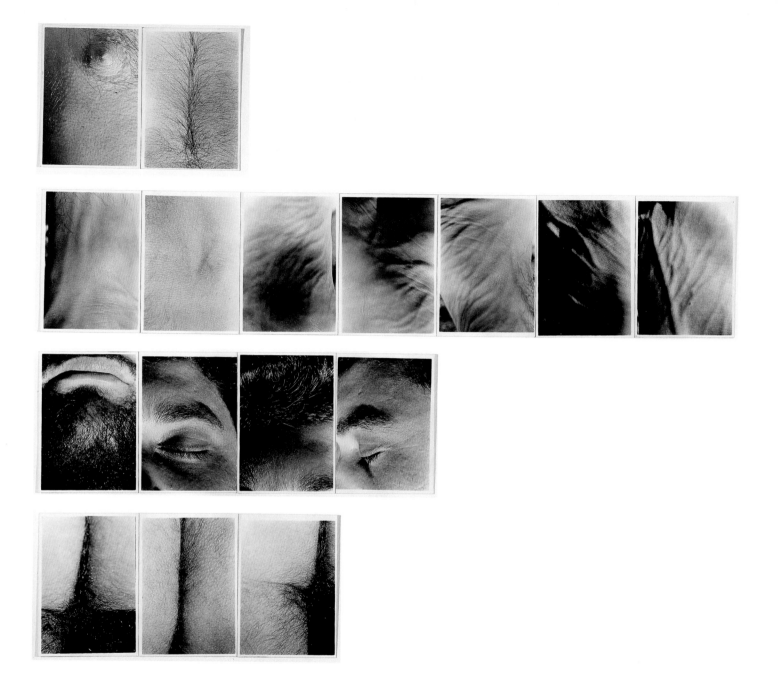

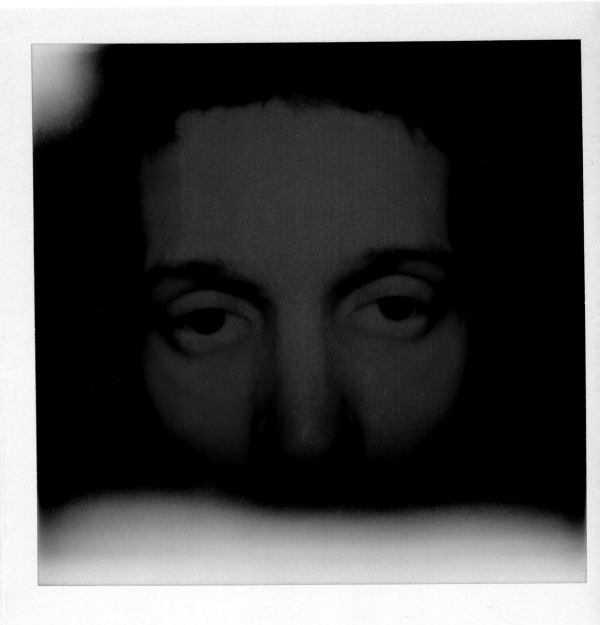

PLATE 3 *Eugene*, 1976, 2 Polaroid SX-70s, 4¹/₂ x 3¹/₂ inches (11.4 x 8.9 cm) each

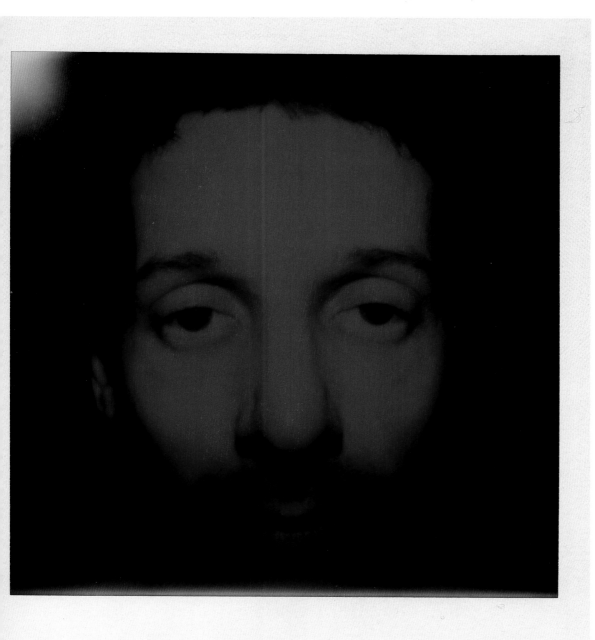

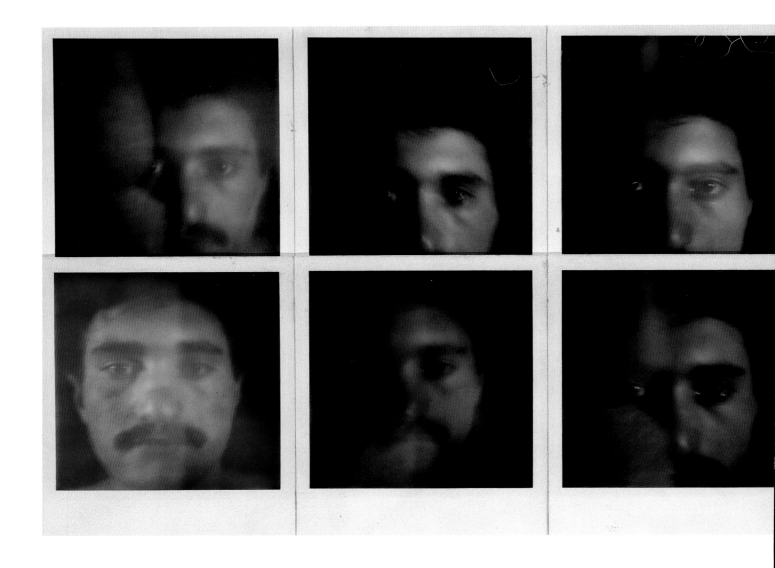

PLATE 4 *Self-Portrait*, 1976, 10 Polaroid SX-70s, 4 1/2 x 3 1/2 inches (11.4 x 8.9 cm) each

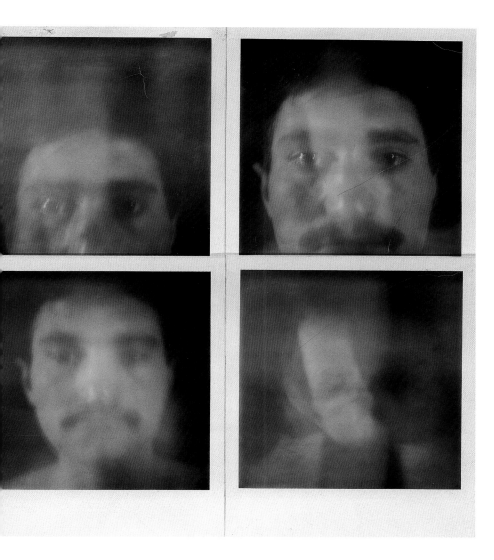

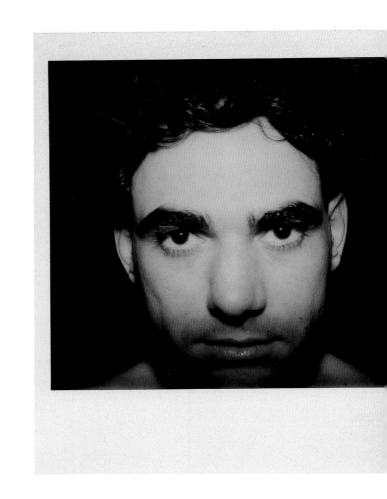

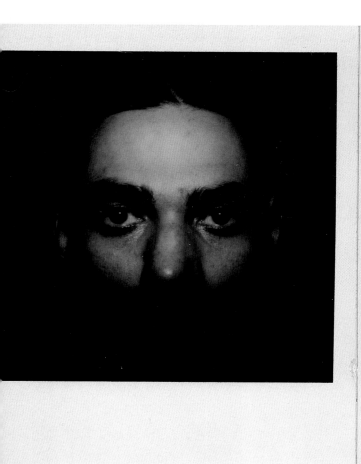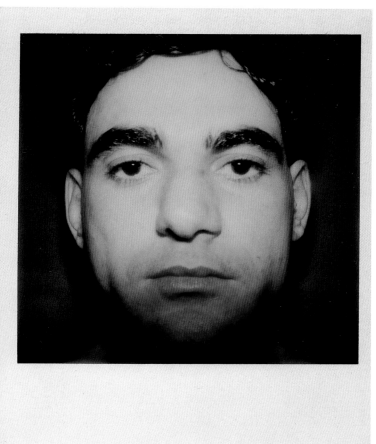

PLATE 5 *John*, 1977, 3 Polaroid SX-70s, 4 ½ x 3 ½ inches (11.4 x 8.9 cm) each

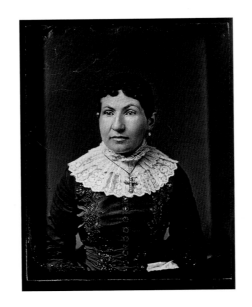
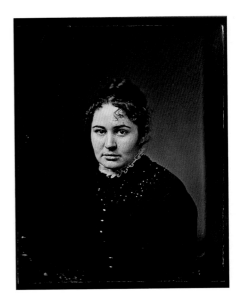
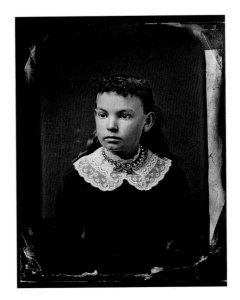

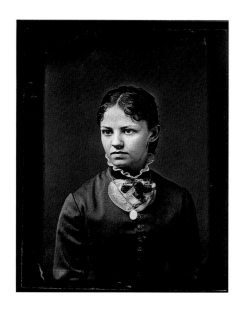
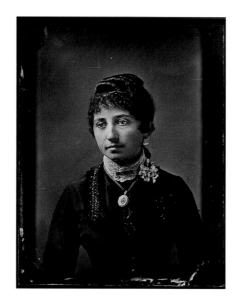
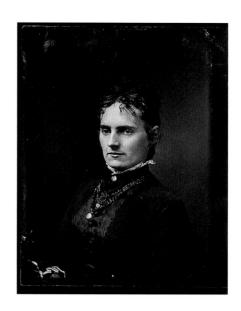
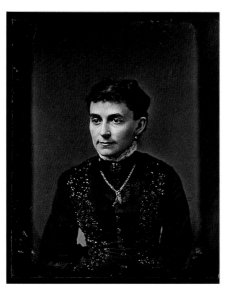
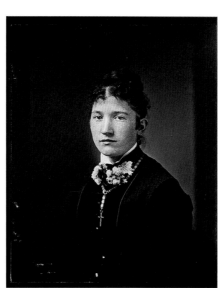
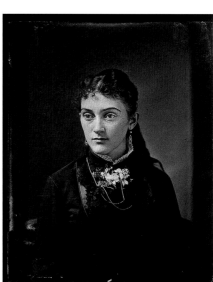

PLATE 6 *Carte de Visite*, 1990, 9 gelatin silver prints, 37 1/2 x 28 1/16 inches (95.3 x 71.3 cm) each

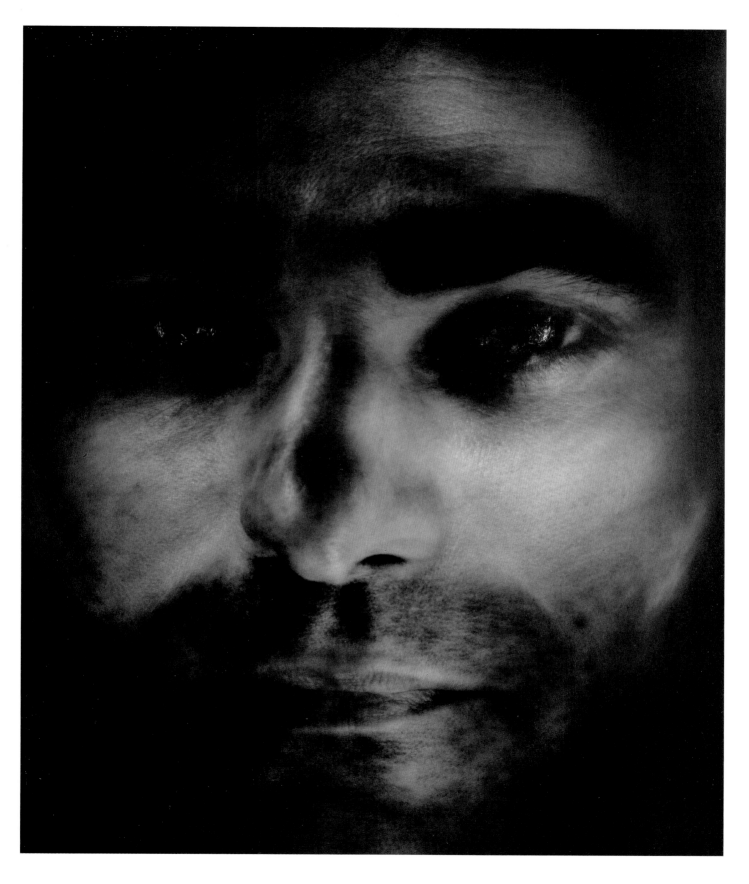

PLATE 7 *John*, 1989, gelatin silver print, 36 x 29 inches (91.4 x 73.7 cm)

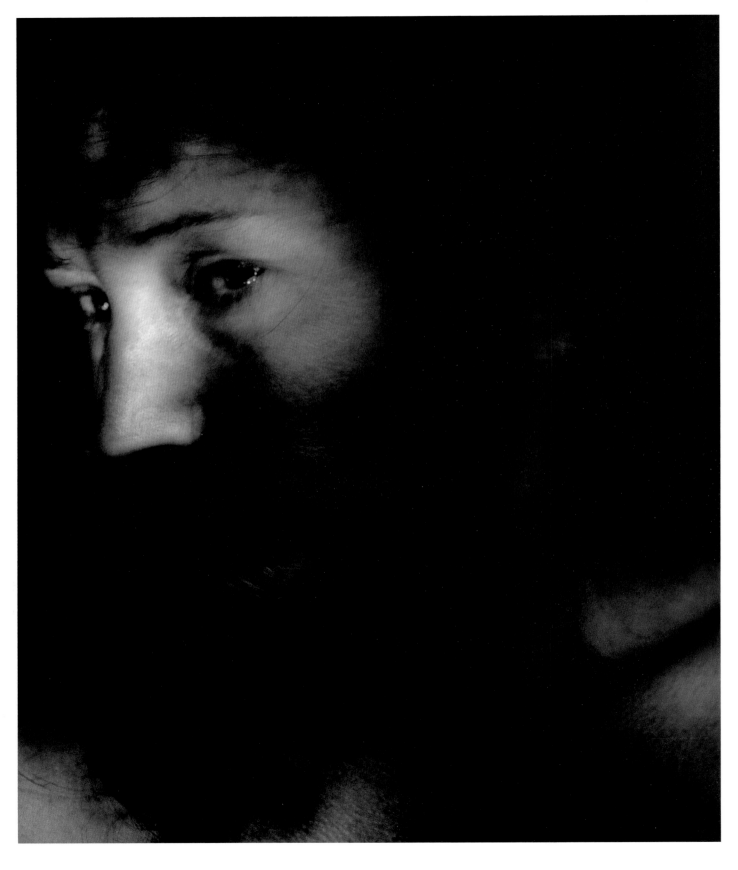

PLATE 8 *Lynne*, 1990, gelatin silver print, 10 x 8 inches (25.4 x 20.3 cm)

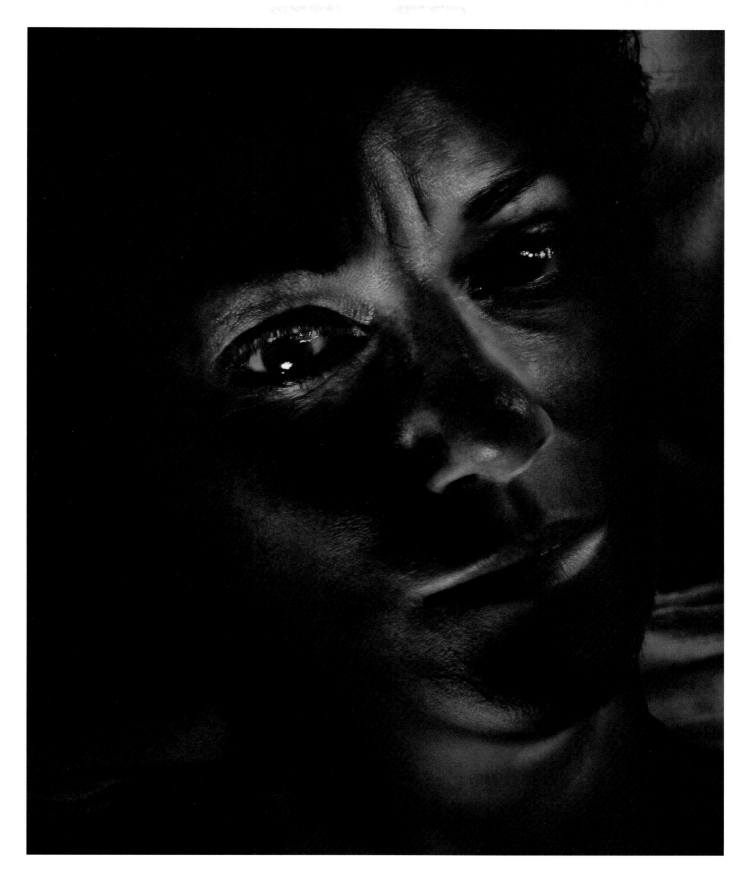

PLATE 9 *Telma*, 1990, gelatin silver print, 36 x 29 inches (91.4 x 73.7 cm)

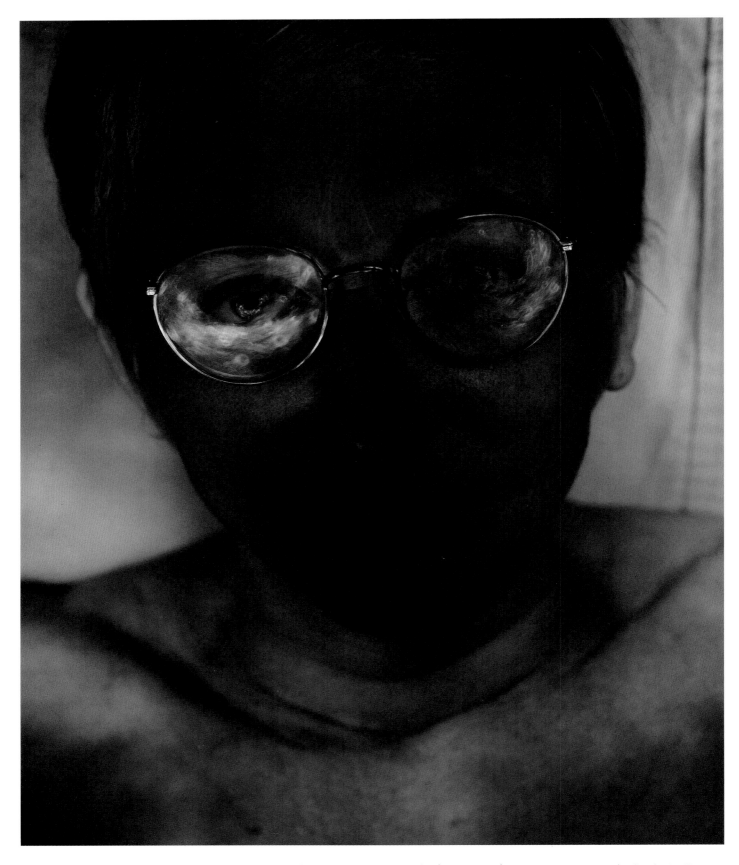

PLATE 10 *Shirley*, 1991, gelatin silver print, 36 x 29 inches (91.4 x 73.7 cm), Fogg Art Museum, Harvard University Art Museums, Davis Pratt Fund and Fund for the Acquisition of Photographs

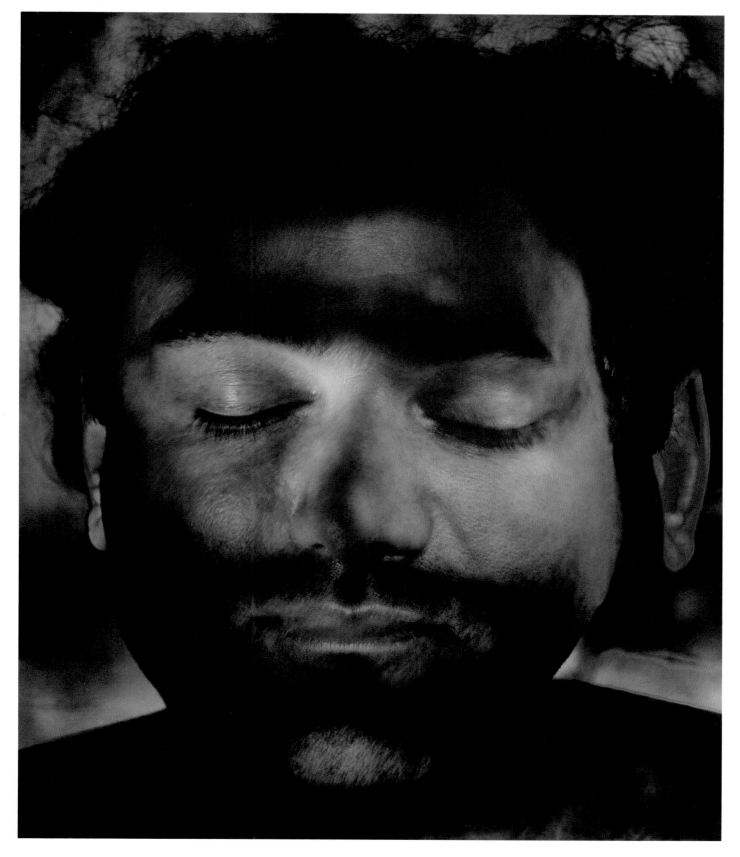

PLATE 11 *John with His Eyes Closed*, 1992, gelatin silver print, 10 x 8 inches (25.4 x 20.3 cm)

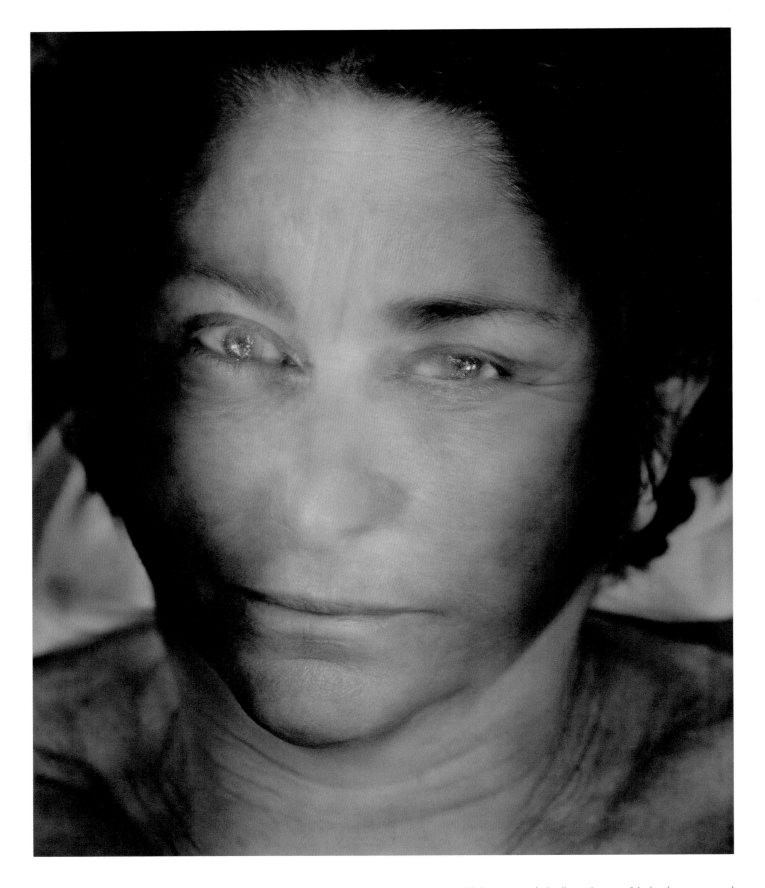

PLATE 12 *Mirriam*, 1993, gelatin silver print, 10 x 8 inches (25.4 x 20.3 cm)

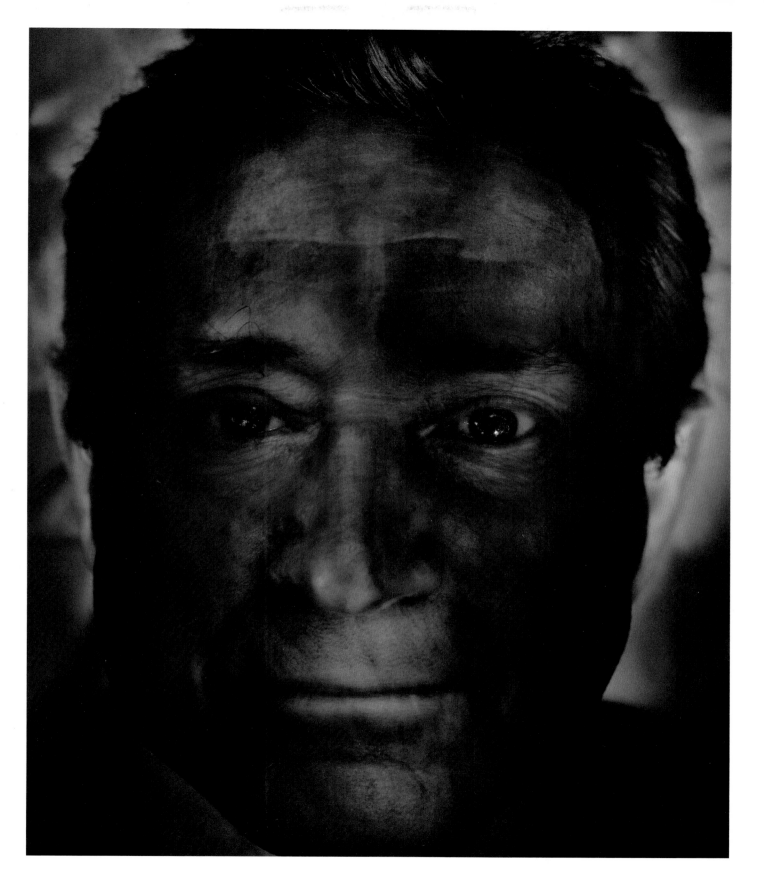

PLATE 13 *Reuben*, 1993, gelatin silver print, 10 x 8 inches (25.4 x 20.3 cm)

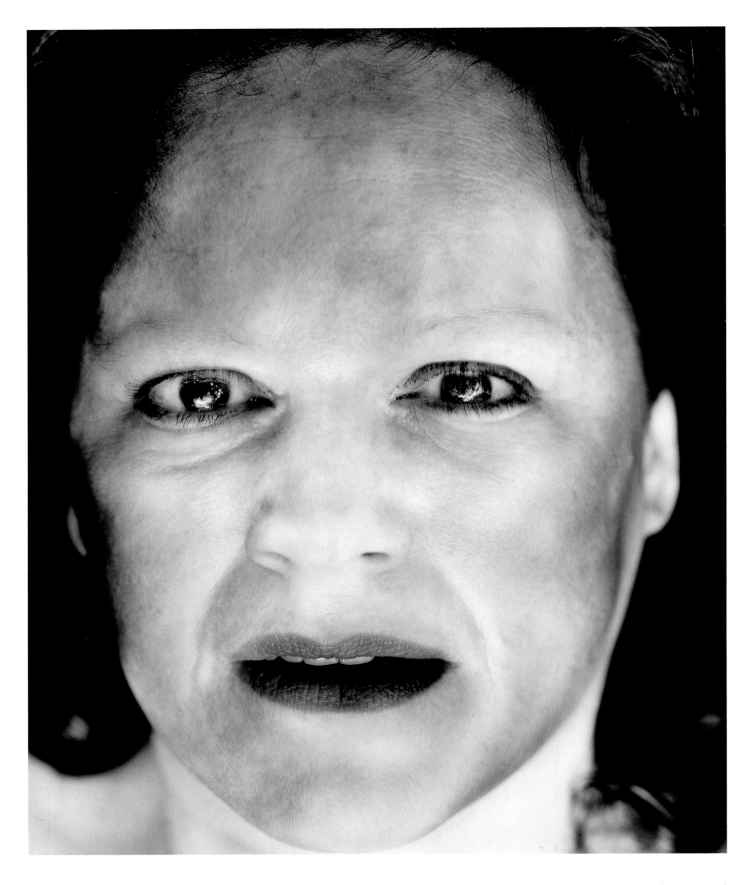

PLATE 14 *Peyton*, 1994, gelatin silver print, 36 x 29 inches (91.4 x 73.7 cm)

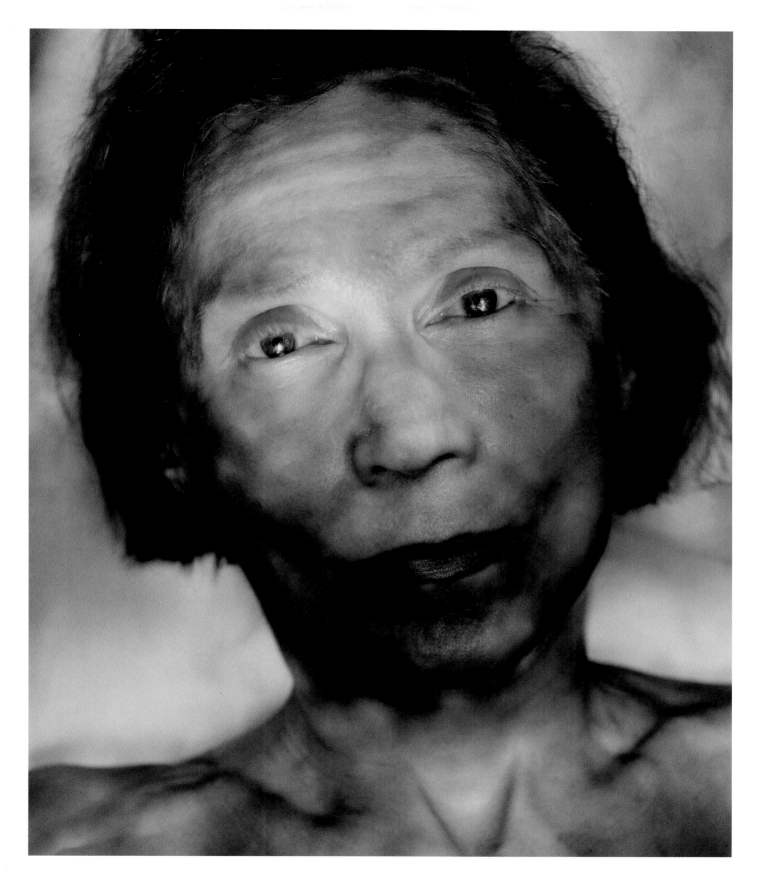

PLATE 15 *Helen*, 1994, gelatin silver print, 36 x 29 inches (91.4 x 73.7 cm)

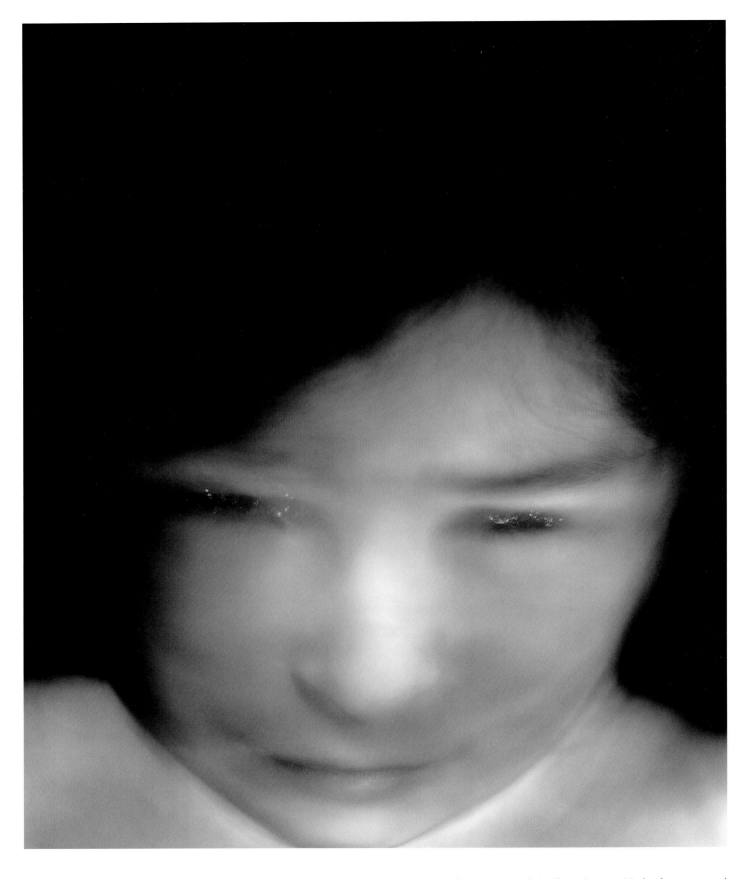

PLATE 16 *Anya*, 1994, gelatin silver print, 10 x 8 inches (25.4 x 20.3 cm)

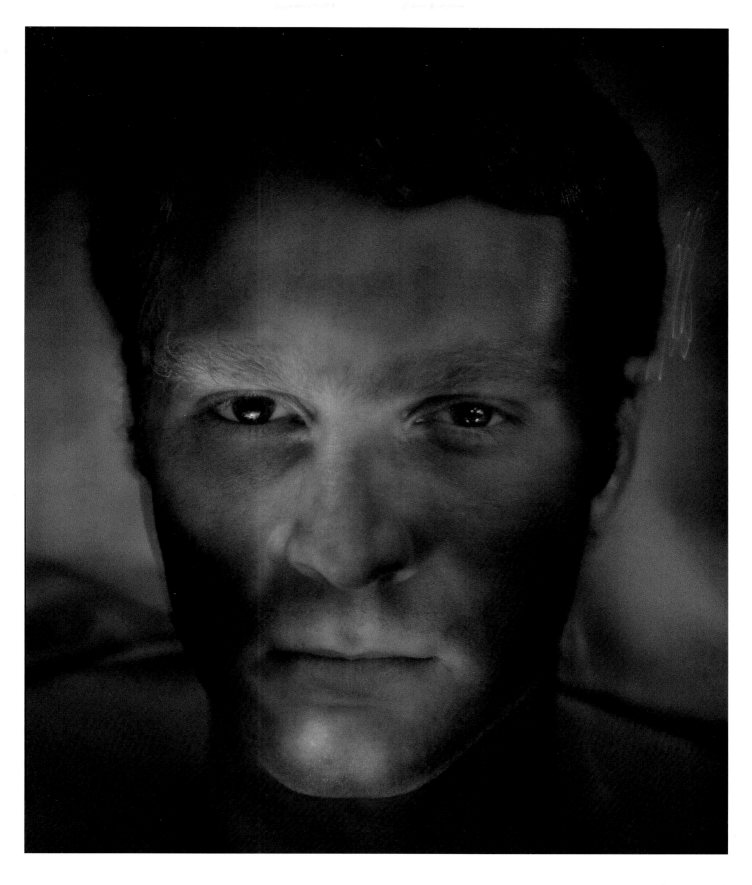

PLATE 17 *Ueli*, 1995, gelatin silver print, 10 x 8 inches (25.4 x 20.3 cm)

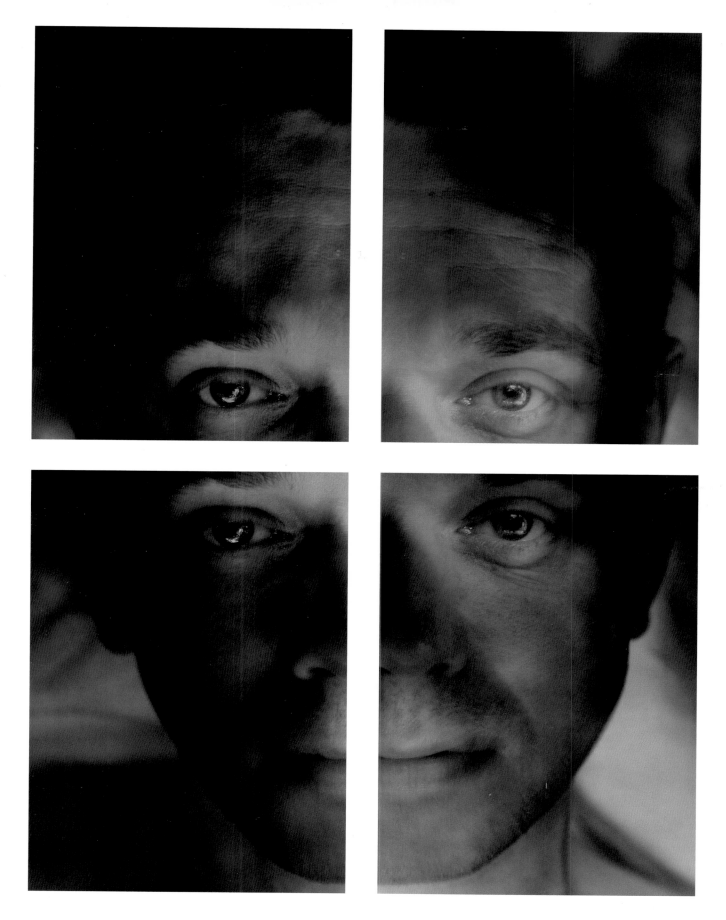

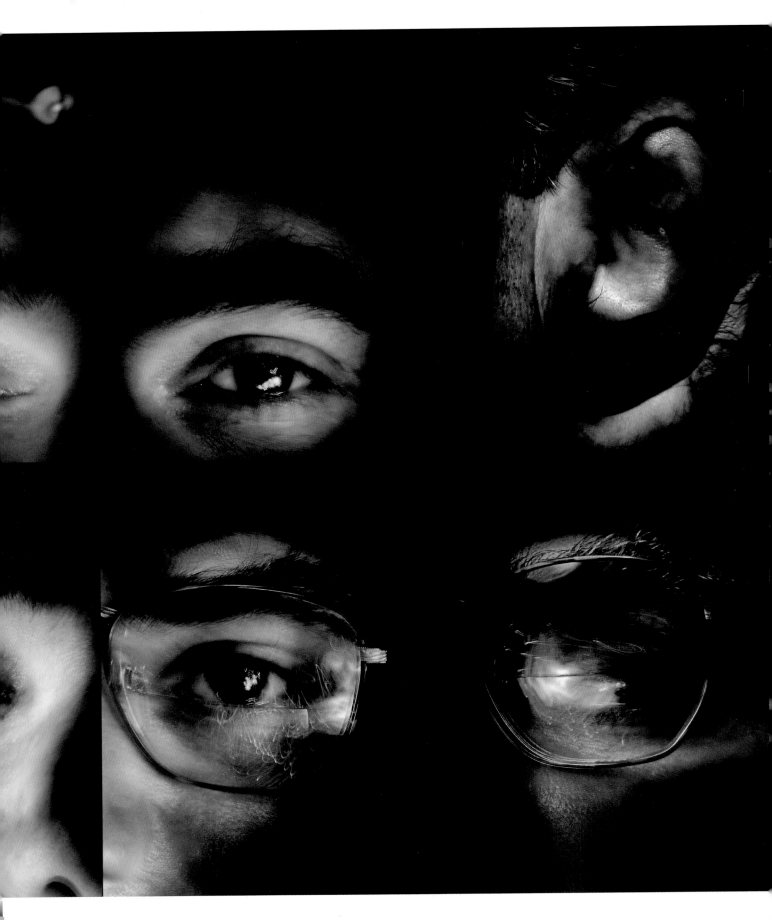

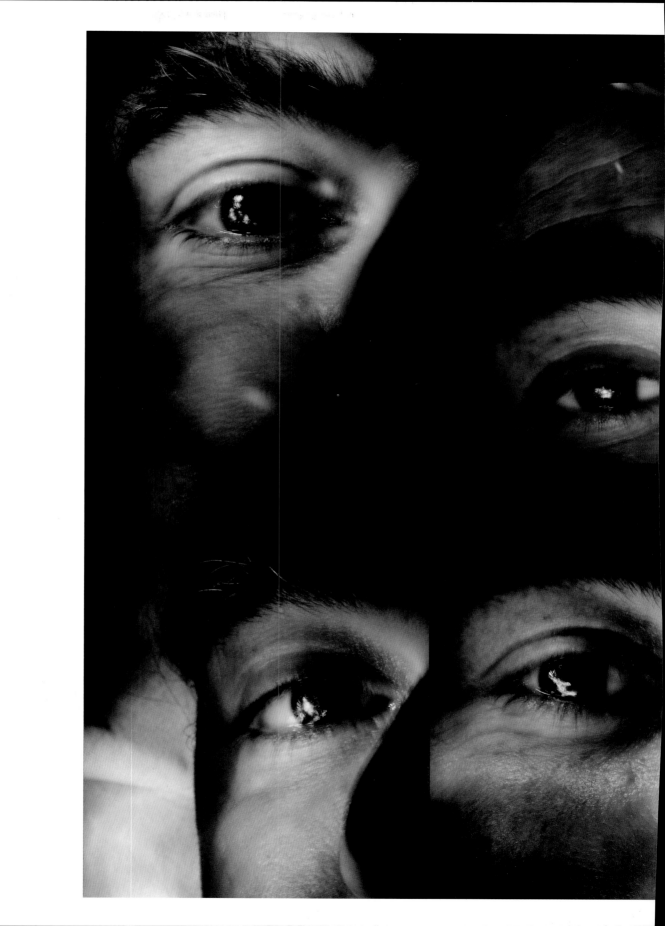

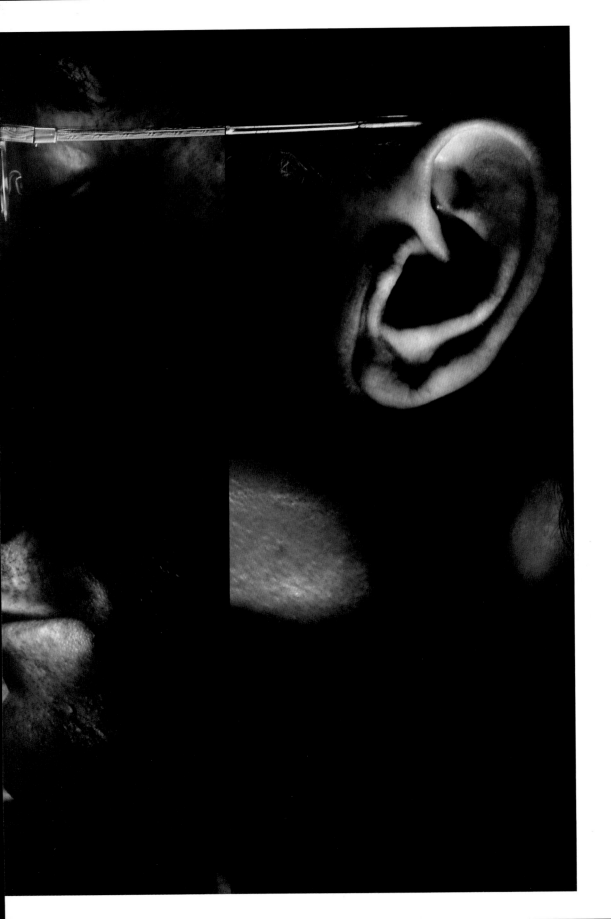

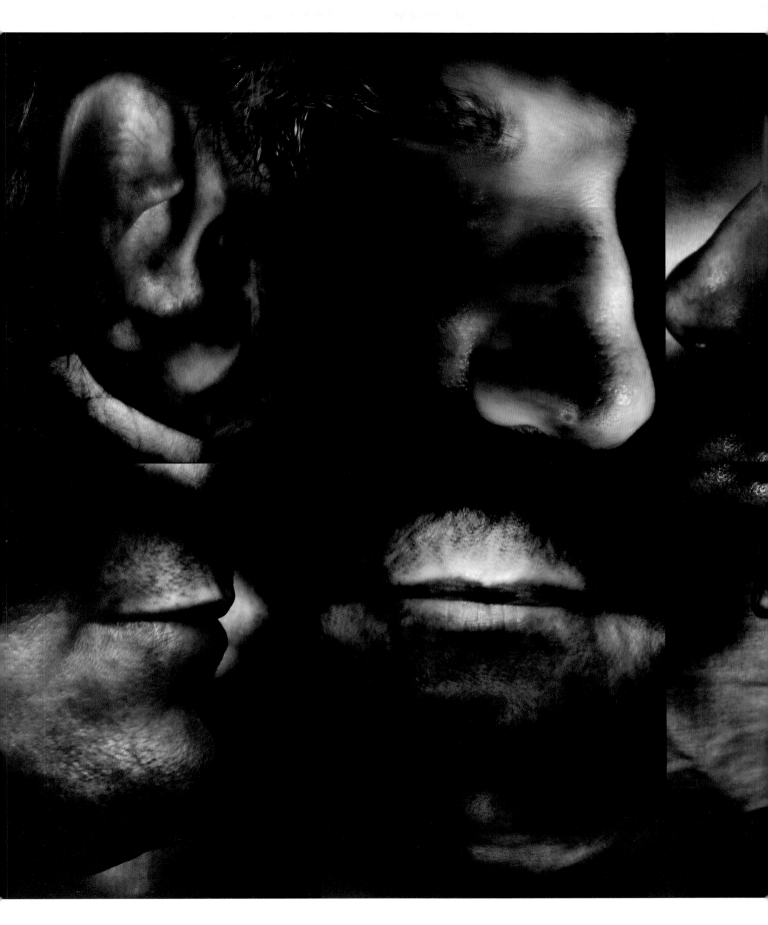

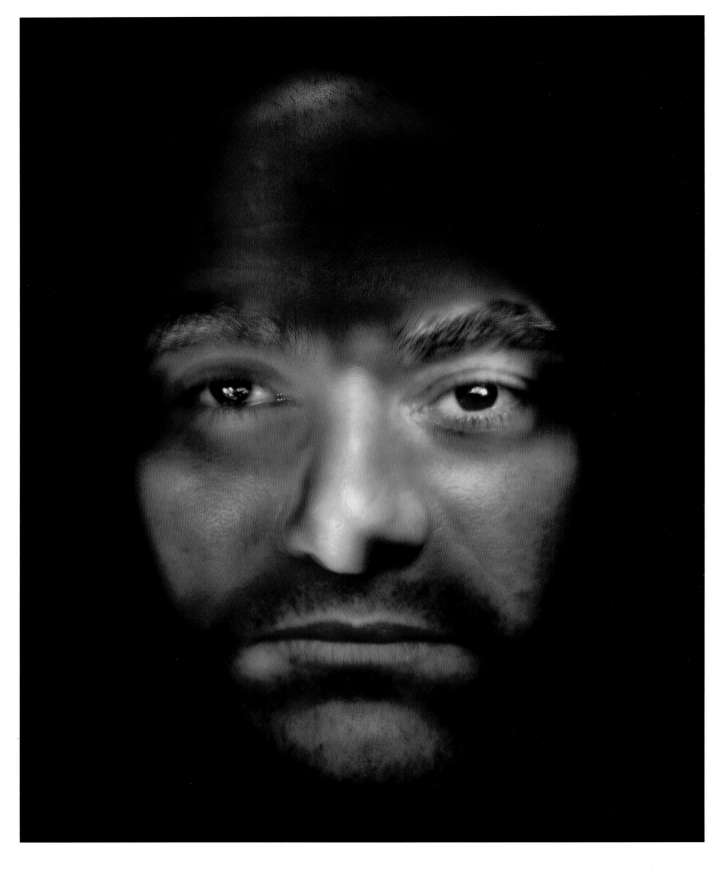

PLATE 20 *John*, 1999, chromogenic print, 60 x 48 inches (152.4 x 121.9 cm)

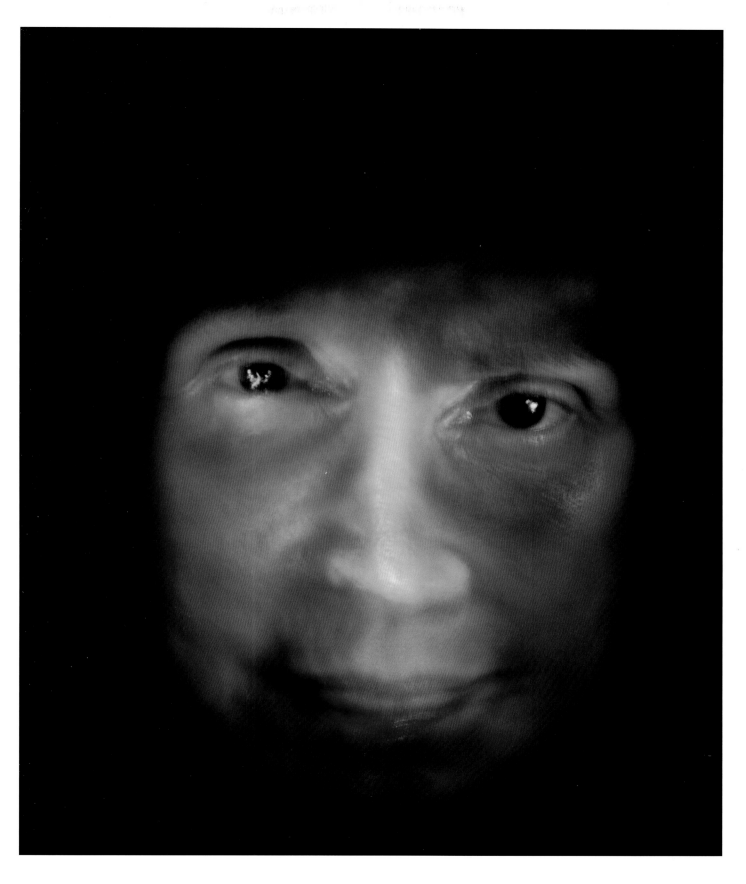

PLATE 21 *Helen*, 2000, chromogenic print, 60 x 48 inches (152.4 x 121.9 cm)

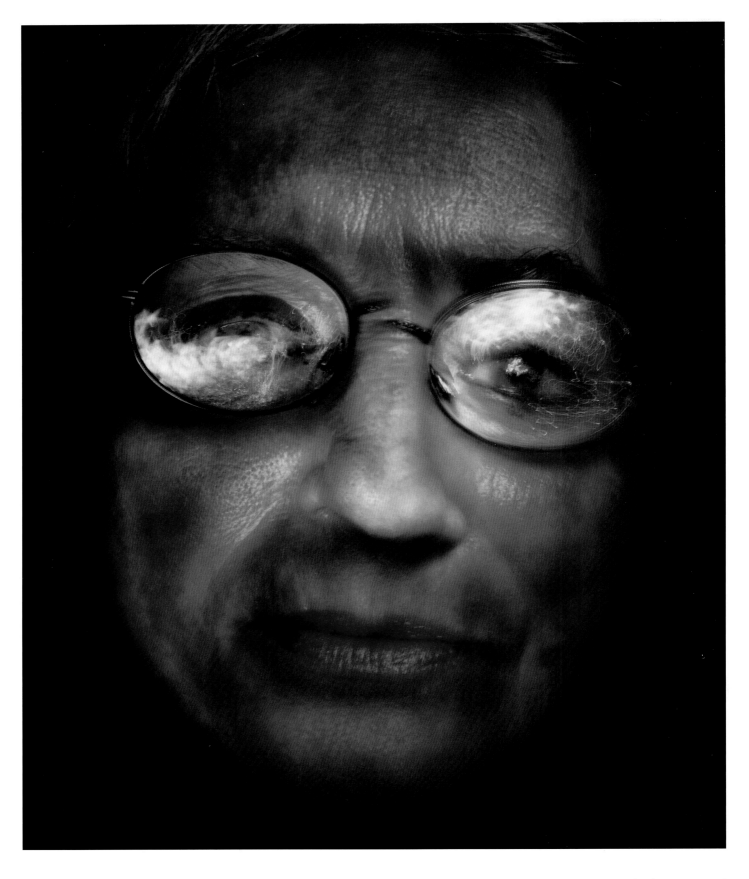

PLATE 22 *Shirley*, 2000, chromogenic print, 60 x 48 inches (152.4 x 121.9 cm)

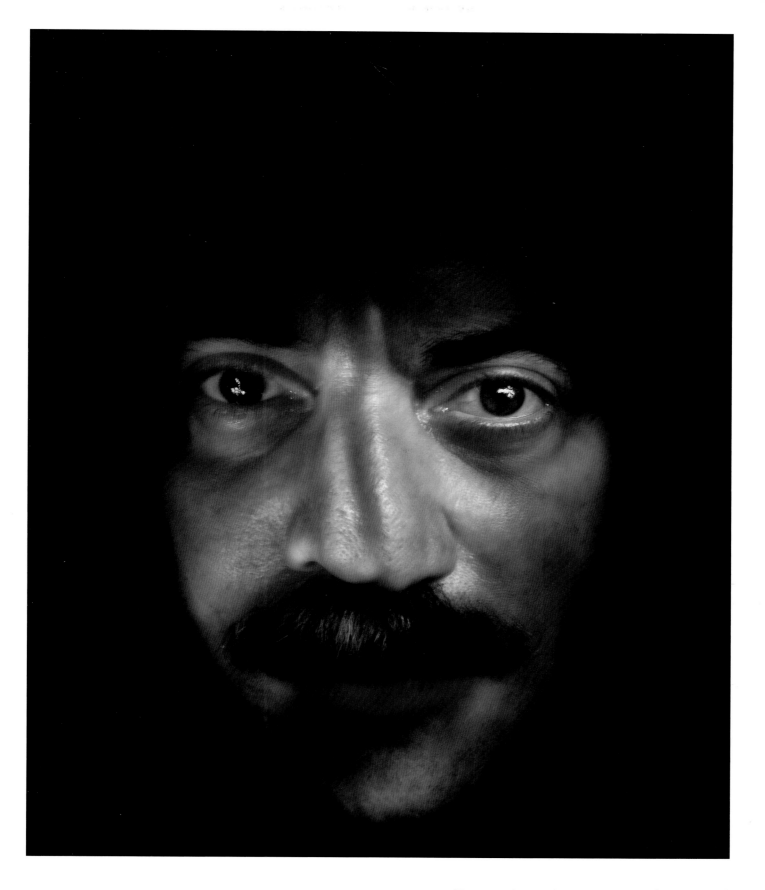

PLATE 23 *Vince*, 2001, chromogenic print, 60 x 48 inches (152.4 x 121.9 cm)

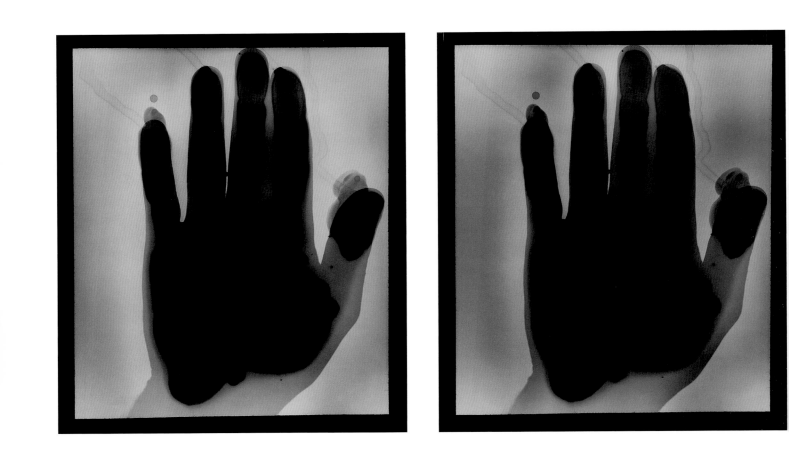

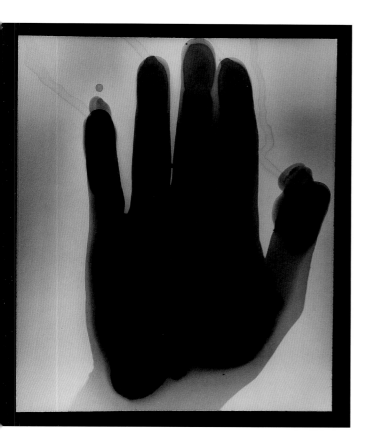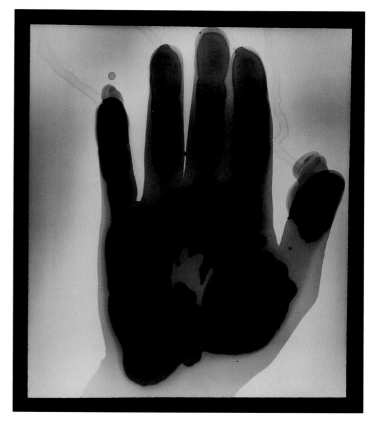

PLATE 24 *Meditations*, 1993, 4 unique gelatin silver prints, 35 ½ x 28 ½ inches (90.2 x 72.4 cm) each, Fogg Art Museum, Harvard University Art Museums, Davis Pratt Fund and Richard and Ronay Menschel Fund for the Acquisition of Photographs

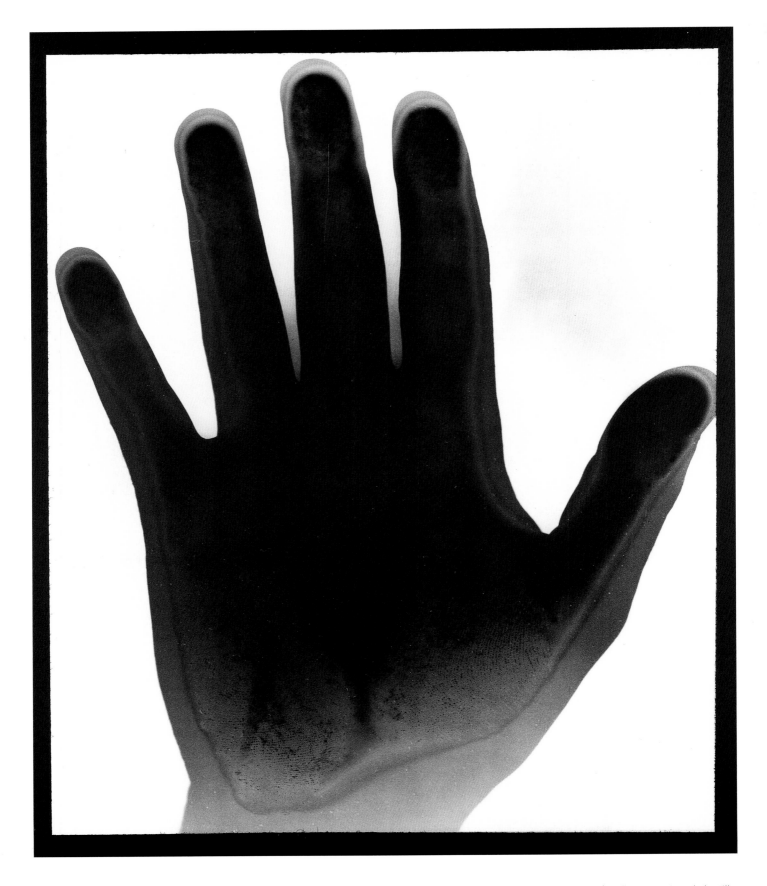

PLATE 25 *After Peter Winter*, 1993, unique gelatin silver print, 35 1/2 x 28 1/2 inches (90.2 x 72.4 cm), Collection Zavie and Ida Miller

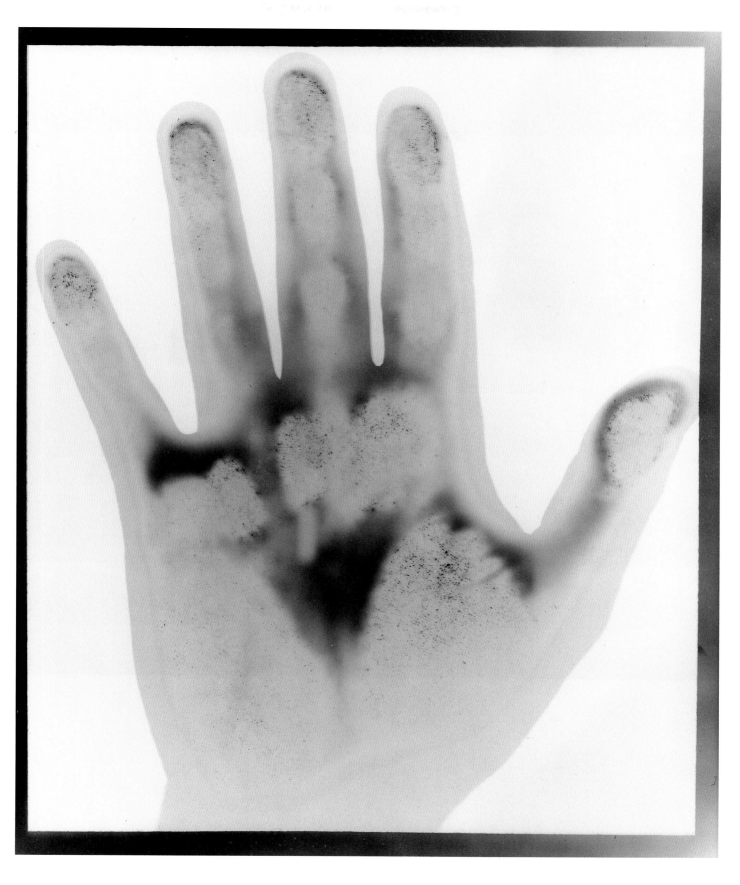

PLATE 26 *After Ethyl*, 1993, unique gelatin silver print, 35 1/2 x 28 1/2 inches (90.2 x 72.4 cm)

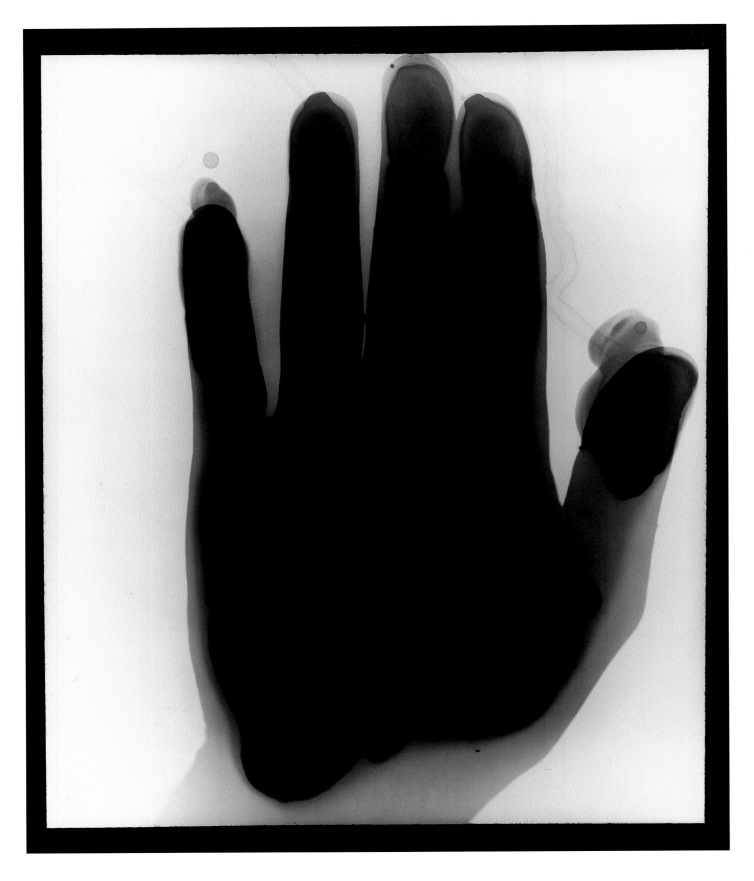

PLATE 27 *After Peter Fall*, 1993, unique gelatin silver print, 35 ½ x 28 ½ inches (90.2 x 72.4 cm), Whitney Museum of American Art, New York, Gift of John Erdman 99.111

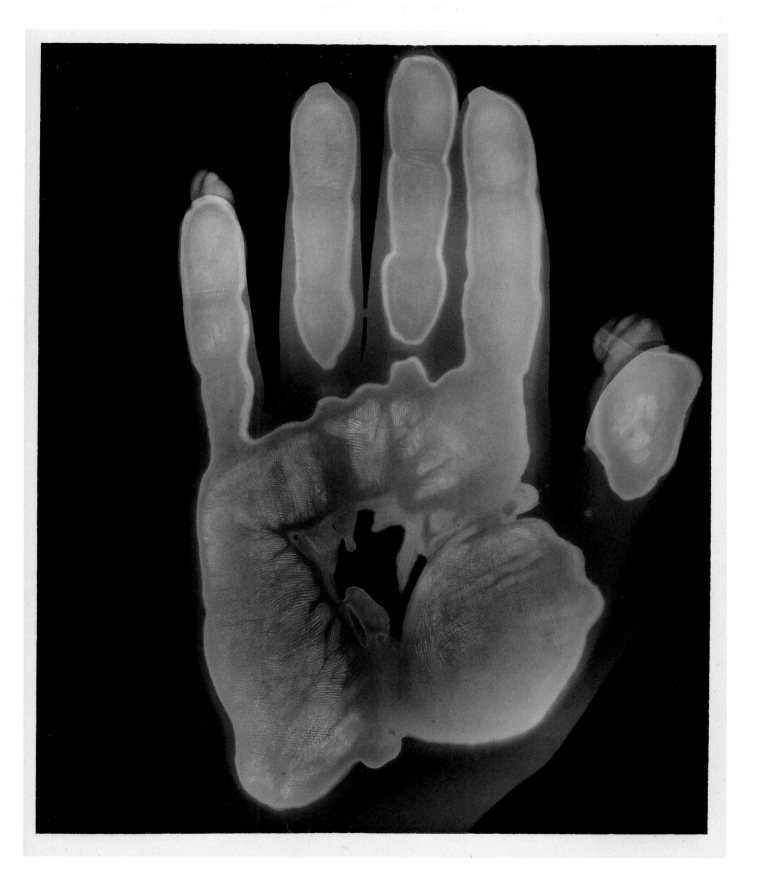

PLATE 28 *After Bill*, 1994, unique gelatin silver print, 35 1/2 x 28 1/2 inches (90.2 x 72.4 cm), Collection of Barry Singer

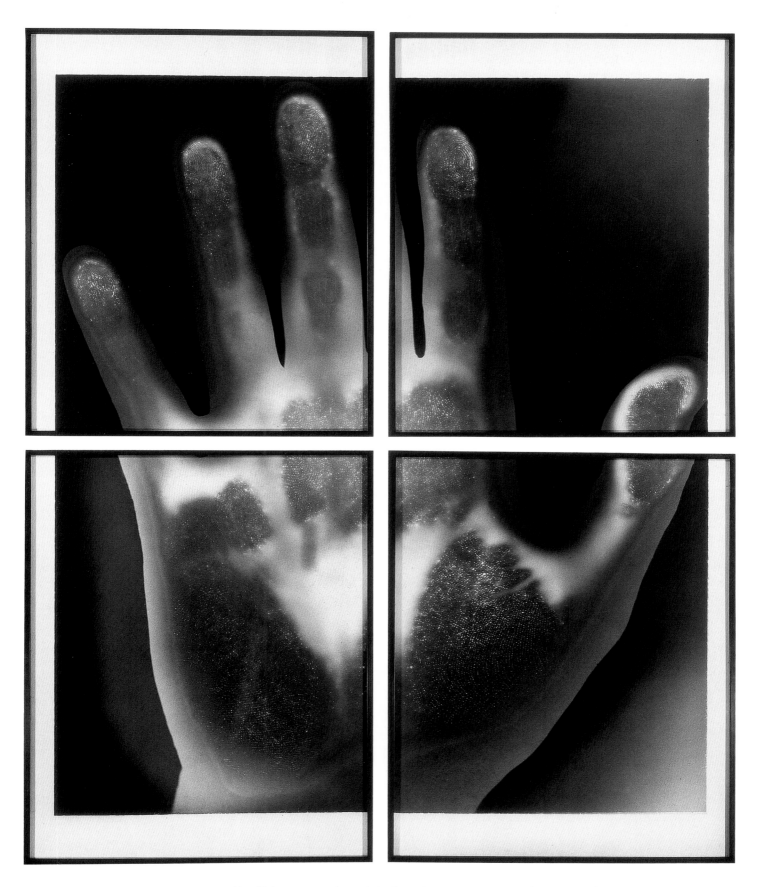

PLATE 29 *After Mirriam*, 1994, 4 unique gelatin silver prints, 35 1/2 x 28 1/2 inches (90.2 x 72.4 cm) each, Collection of Henry Buhl

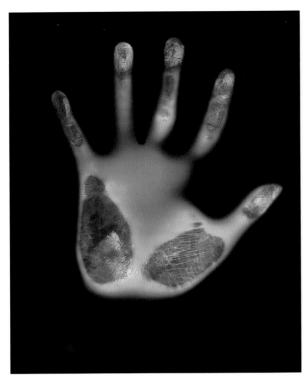 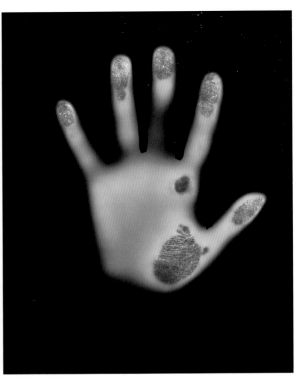

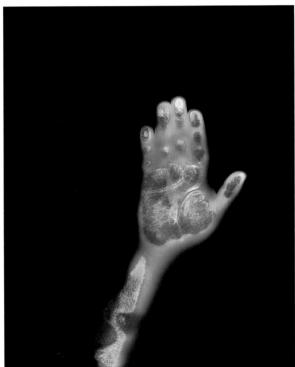

PLATE 30 *Barron Family Portrait (Alton, Carrie; Chloe),* 1996, 3 gelatin silver prints, 10 x 8 inches (25.4 x 20.3 cm) each

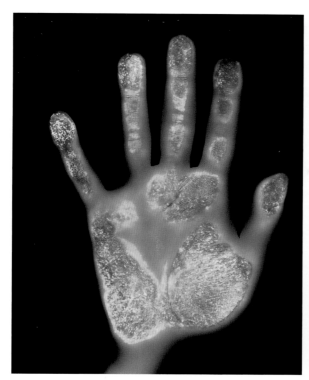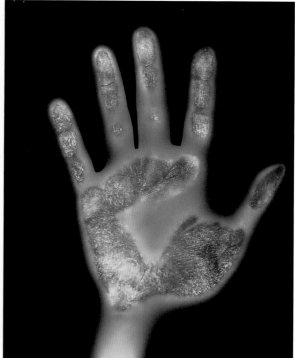

PLATE 31 *Charlie and Joe*, 1996, 2 gelatin silver prints, 10 x 8 inches (25.4 x 20.3 cm) each

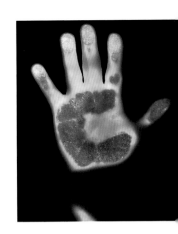

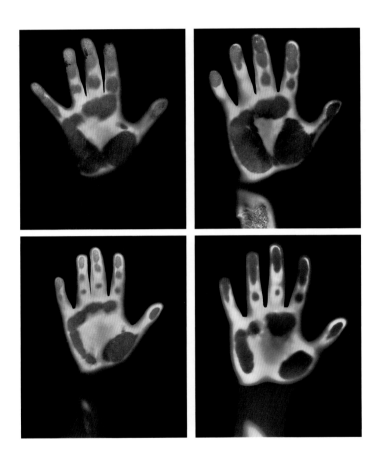

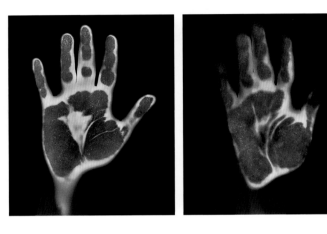

PLATE 32 *Schneider Family Portrait (Reuben, Rhona; Lesley, Eric, Gary, John, Marlene, William, Adrienne, Roy; Nicole, Brett, Jaime, Erica, Gavin, Carly; Alexa at Five Months)* 2002, 17 gelatin silver prints; 1 family tree panel, 10 x 8 inches (25.4 x 20.3 cm) each

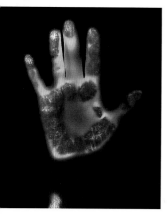
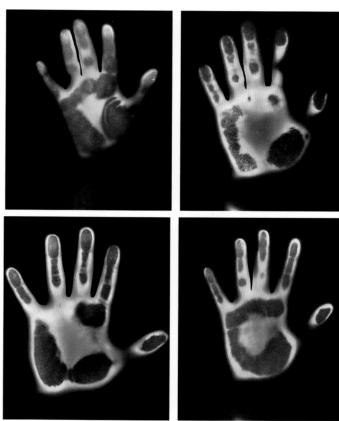
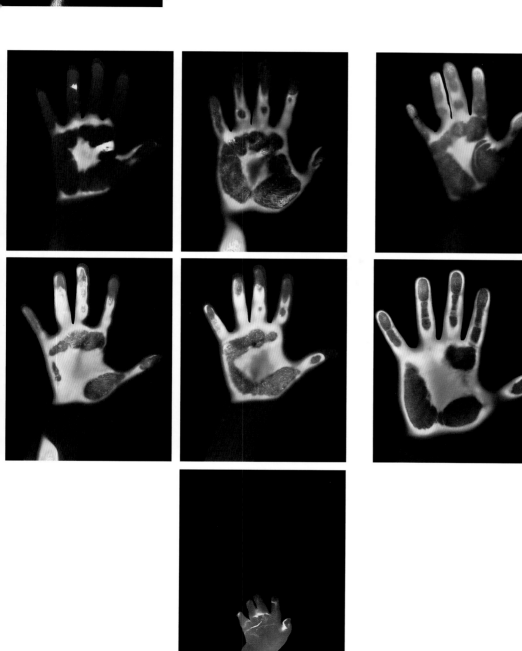

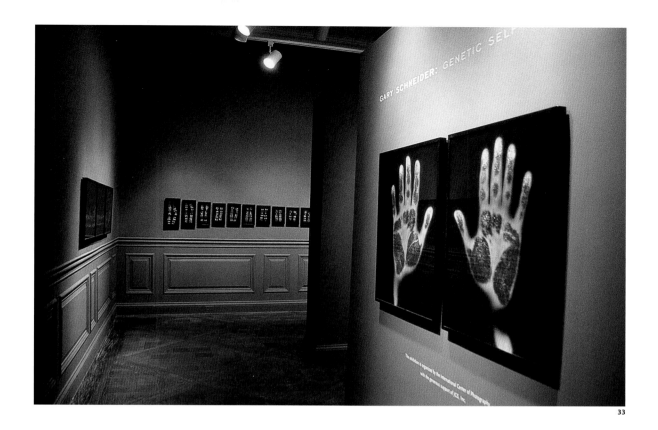

33

34

PLATES 33–38 Installation views of *Genetic Self-Portrait* (1997–98) at the International Center of Photography, New York, 19 February – 9 April 2000; 14 images made up of 55 gelatin silver prints and platinum/palladium prints of various sizes

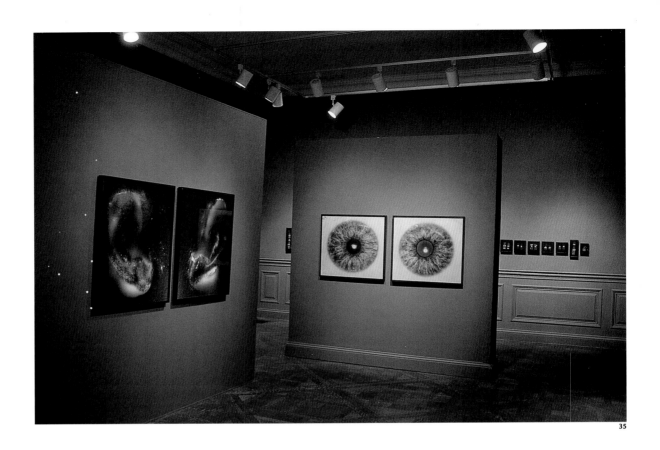

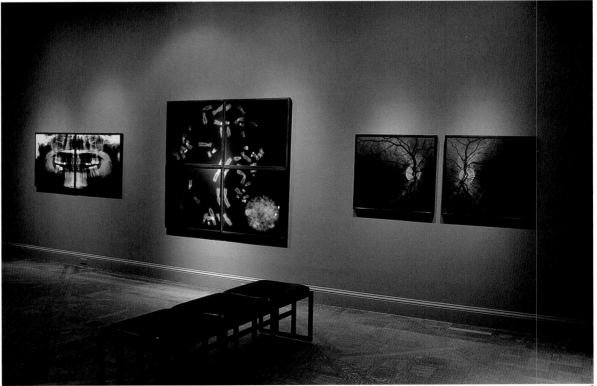

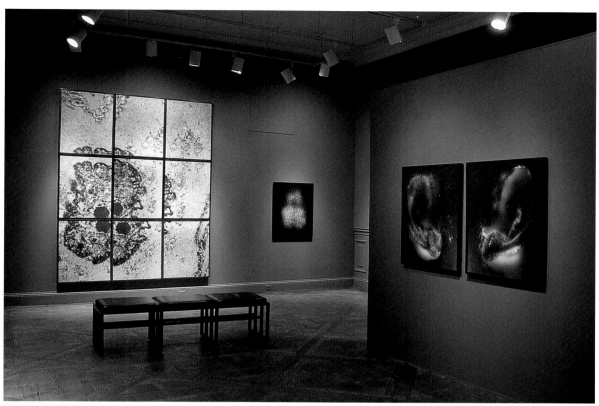

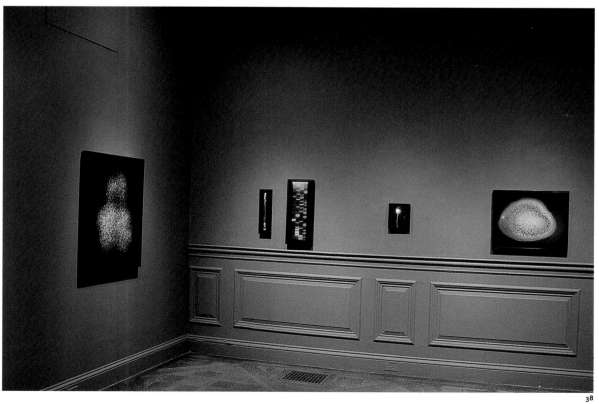

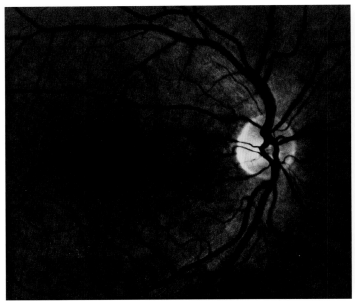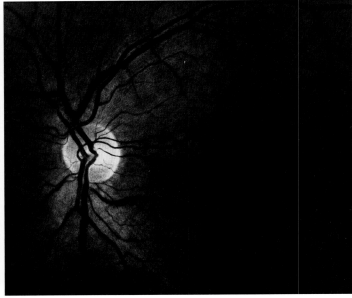

PLATE 39 *Retinas*, 1998, from *Genetic Self-Portrait*, 2 gelatin silver prints, 29 x 31 inches (73.7 x 78.7 cm) each

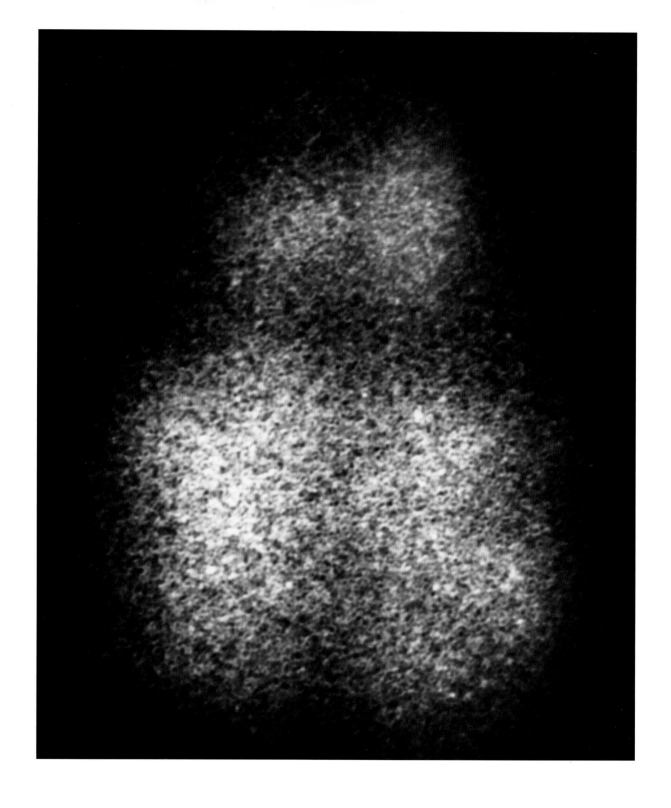

PLATE 40 *DNA DYZ3/DYZ1*, 1998, from *Genetic Self-Portrait*, gelatin silver print, 36 x 29 inches (91.4 x 73.7 cm)

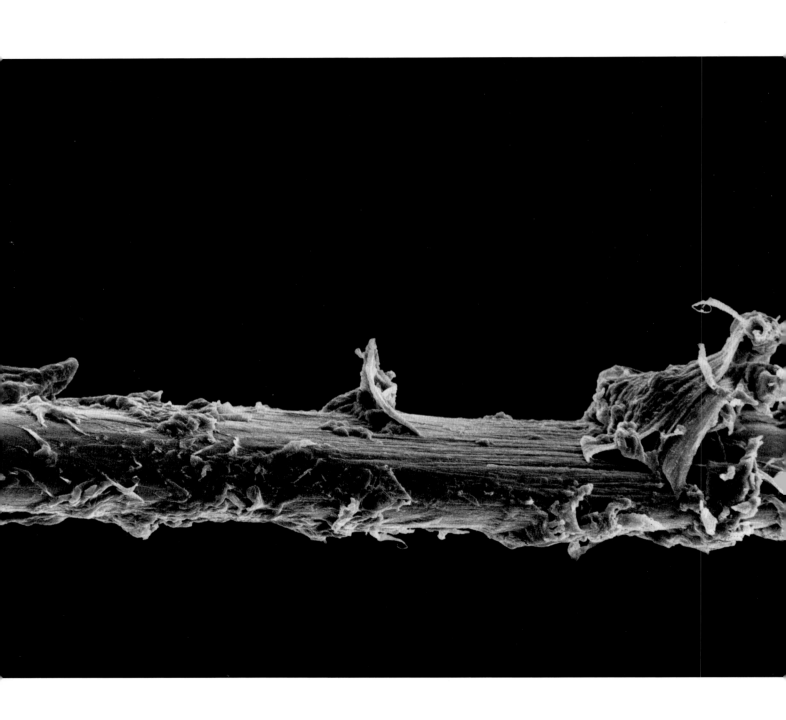

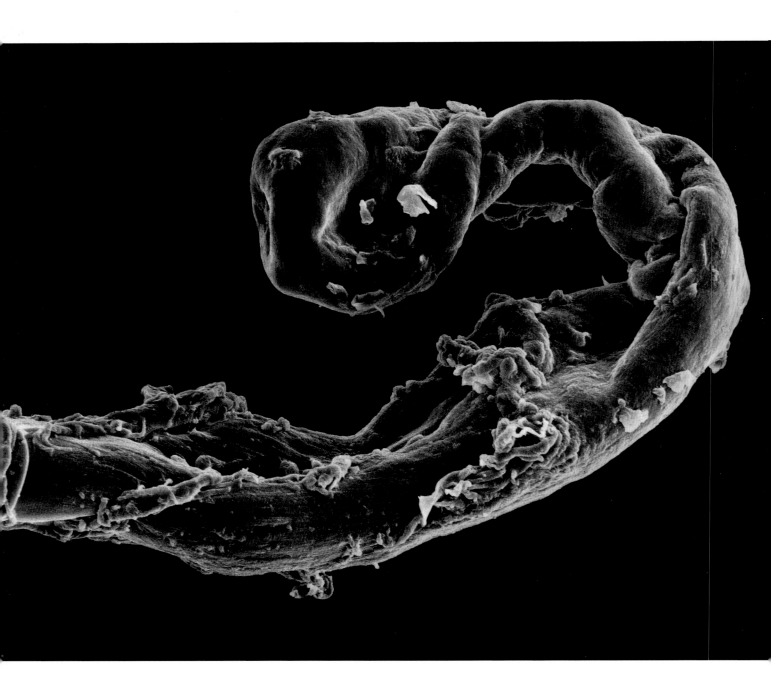

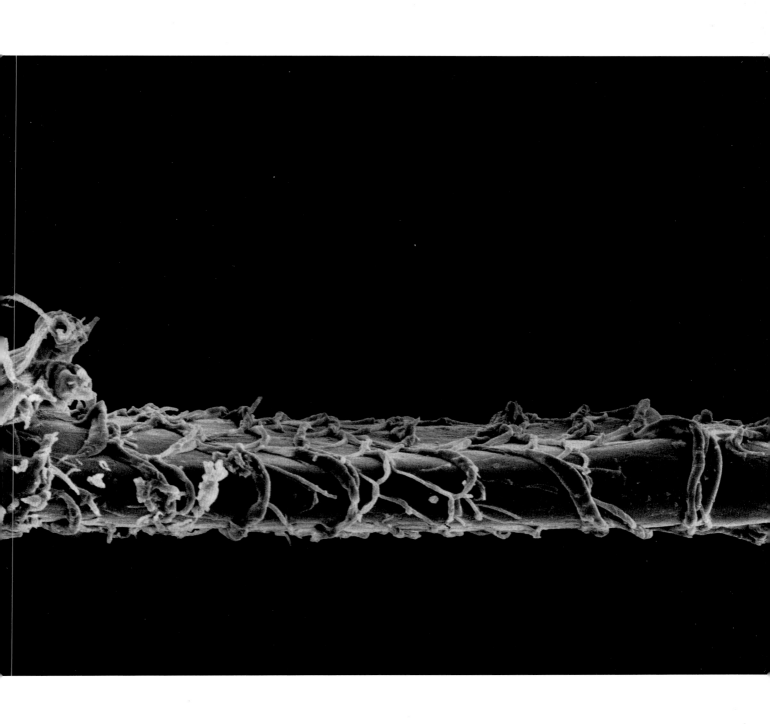

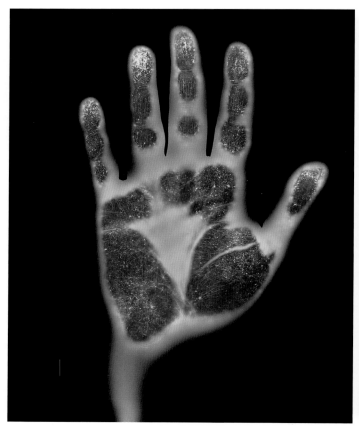
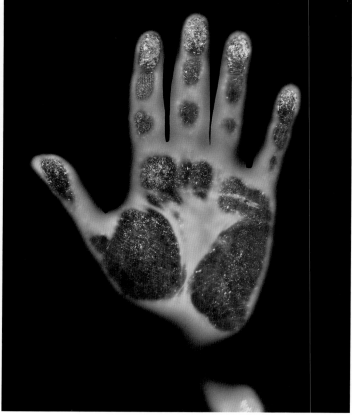

PLATE 42 *Hands,* 1997, from *Genetic Self-Portrait,* 2 gelatin silver prints, 36 x 29 inches (91.4 x 73.7 cm) each

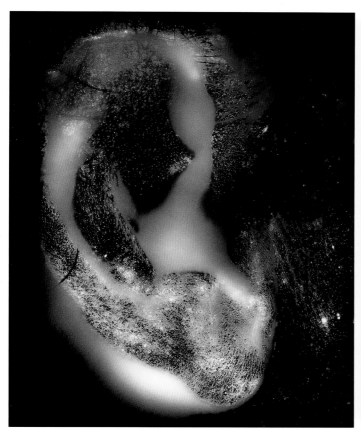
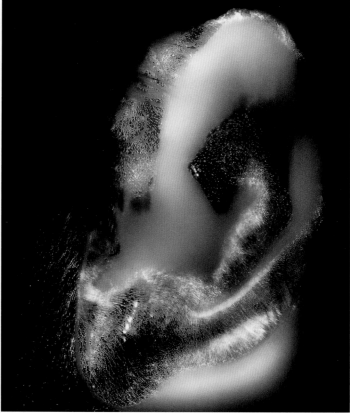

PLATE 43 *Ears*, 1997, from *Genetic Self-Portrait*, 2 gelatin silver prints, 36 x 29 inches (91.4 x 73.7 cm) each

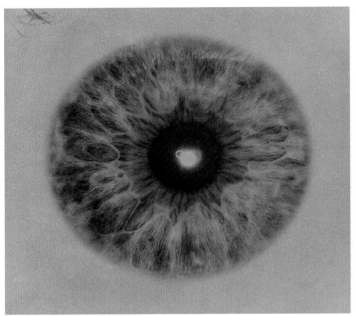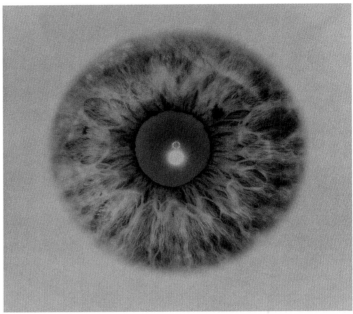

PLATE 44 *Irises*, 1997, from *Genetic Self-Portrait*, 2 gelatin silver prints, 29 x 31 inches (73.7 x 78.7 cm) each

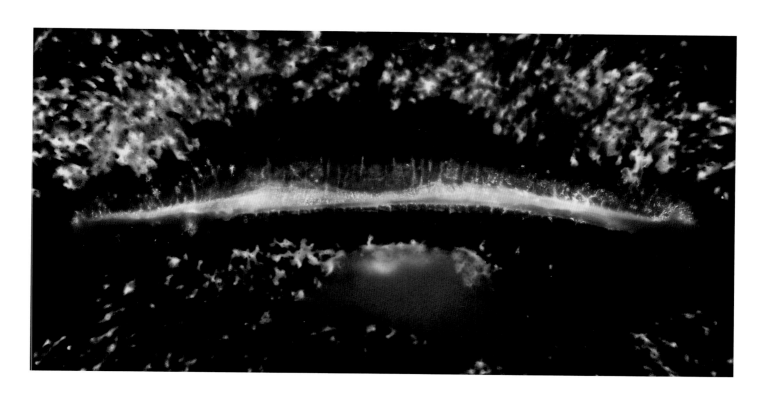

PLATE 45 *Lips Self-Portrait*, 2000, later addition to *Genetic Self-Portrait*, gelatin silver print, 19 $\frac{1}{2}$ x 39 inches (49.5 x 99.1 cm)

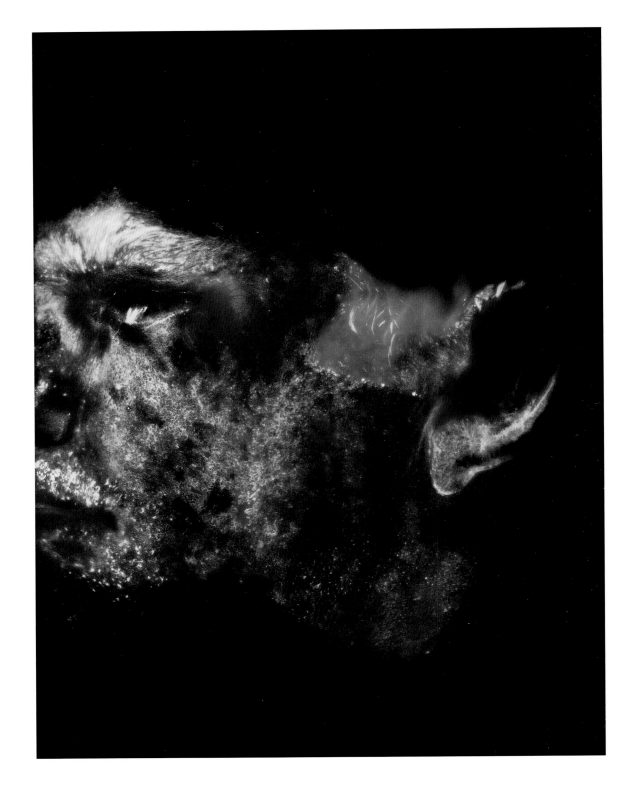

PLATE 46 *Mask*, 1999, later addition to *Genetic Self-Portrait*, gelatin silver print, 36 x 29 inches (91.4 x 73.7 cm)

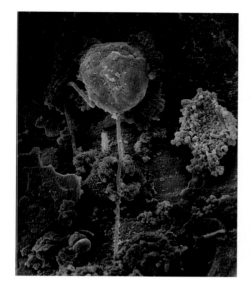 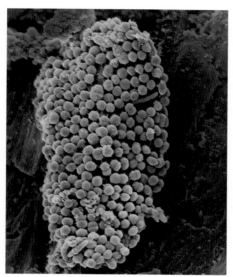 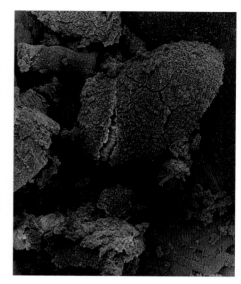

PLATE 47 *Intestinal Flora*, 1999, later addition to *Genetic Self-Portrait*, 3 gelatin silver prints, 10 x 8 inches (25.4 x 20.3 cm) each

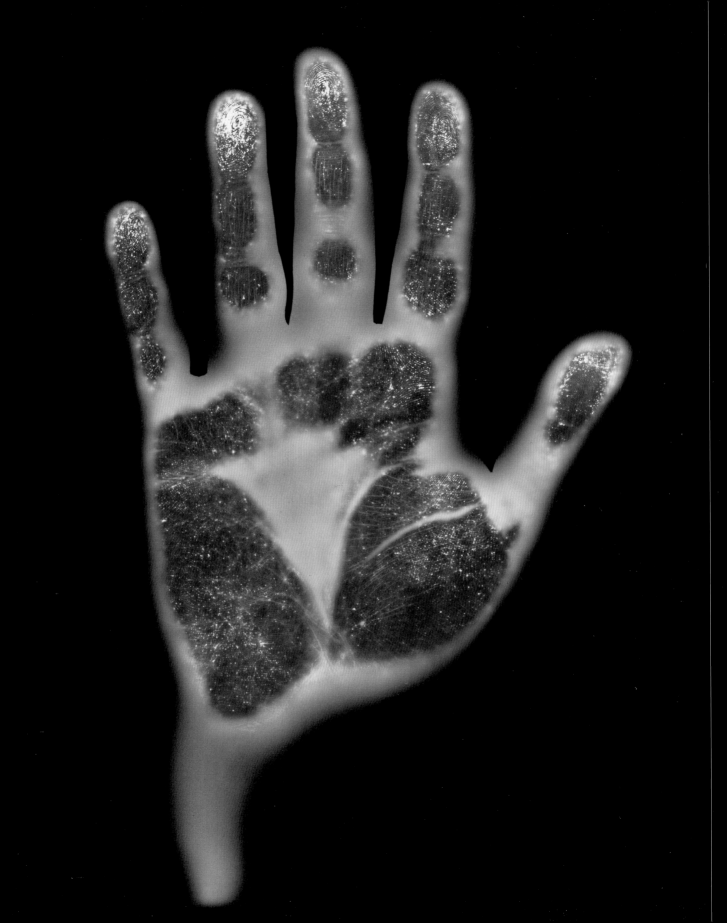

Gary Schneider in Conversation

Edited excerpts from taped conversations between
Gary Schneider and Deborah Martin Kao in 2002

Although I was born in a very small town called East London, I grew up in Cape Town.
The members of my family are all very different from each other, but we are close
knit. I feel very privileged in that way. My mother and my father had dramatic prob-
lems in their youth related to South Africa. My mother's family were the only Jews
in a German town during World War II, and they were constantly given a hard time.
They were both born in South Africa, and their parents were from Lithuania, Lithuanian
Jews. I went to a Jewish day school because everything in South Africa was segre-
gated. If you were Afrikaner you went to an Afrikaner school, English to an English
school — there was social, economic, and race stratification.

I was a shy kid, the youngest in my class, and I learned slowly. I think I was
dyslexic. My mother wanted me to be a doctor, but I struggled through high school.
I rebelled in my junior and senior years. My parents did not allow me to take art
classes in high school, but I would hang around the art class and go to galleries. There
was one gallery in Cape Town that was very sophisticated. It showed people like
Ben Nicholson, Paul Klee, and Morandi. I grew up with a love of Morandi.

My parents collected South African paintings, and as a teenager I began to collect,
too. My bar mitzvah money went to buying art. I would go to auctions — I picked
up an Otto Dix once — and I had a close friend with whom I went to galleries. There
was a huge German population in South Africa and a lot of German influence. The
big South African painters were German Expressionists, like Irma Stern, who studied
in Germany with Max Pechstein.

At the University of Cape Town, in the undergraduate art school, I joined a film
society and became quite involved as a member of the selection committee. We
screened mostly surrealist films. American and Canadian independent film wasn't really
present in South Africa at that time. It was only when I came to New York that I
became aware of it. In a way I came to New York because of *Artforum*. If you live in a

tiny place where there is nothing, you read the magazines. I remember reading *Artforum*. John Coplans was a great editor, and his niece was a school friend of mine; she was a year ahead of me in art school. I read a lot then; that's how I came to know the work of Vito Acconci, Richard Foreman, and Yvonne Rainer.

Growing up in South Africa and being gay, I became interested in constructing my own space to explore my identity and the authenticity of my environment. I think it also goes back to being a very shy kid and hating school. I have vivid memories of not wanting to go to school every day, of really not wanting to be there. For me my work is a way to learn how to interact with the world. It's about how I make contact with people in some kind of very essential way rather than by social contract.

The fragmented portraits that I made in art school came out of the art of the 1970s that I admired. I set the camera — 35mm, of course — at a very specific focal distance, very close up, and I made a portrait of my friend Ralph in parts, and then I directed him through a portrait of me. Then I made a portrait of El (fig. 1), and I directed her through a portrait of me, which is really kind of exquisite. I did not conceive them to be installed in any specific arrangement. I didn't think like that then. I arranged them aesthetically after the fact. I have a slide of the exhibition of them at Artists Space in 1977. It also shows my early Polaroid SX-70s, which are all multiple-exposure portraits.

Photography is too easy, generally; it's too easy to make something that just works. I feel very privileged that I went to two art schools rather than to specialist photography schools. I didn't really study photography in art school. I wanted to, because I needed it for my filmmaking, which was my primary interest then. In undergraduate school I had an American photography teacher who had trained with Minor White. He was the most orthodox proponent of the Zone System approach to photography. It's a formal, mathematical approach to measuring light. Because I'm not a mathematician I couldn't understand the Zone System at that level at that time. So I dropped the class in my freshman year. I couldn't do it. I just didn't want to do it.

I teach the opposite of Zone System. I want my students to experience the work and then work out how to improve it technically. I understand Zone System *now*. I've read all the Ansel Adams books. They're really great books; they're amazing. So I think students should just worry about the technical aspects as they go. As long as they're working with a critical eye, they can make their work function. In a lot of

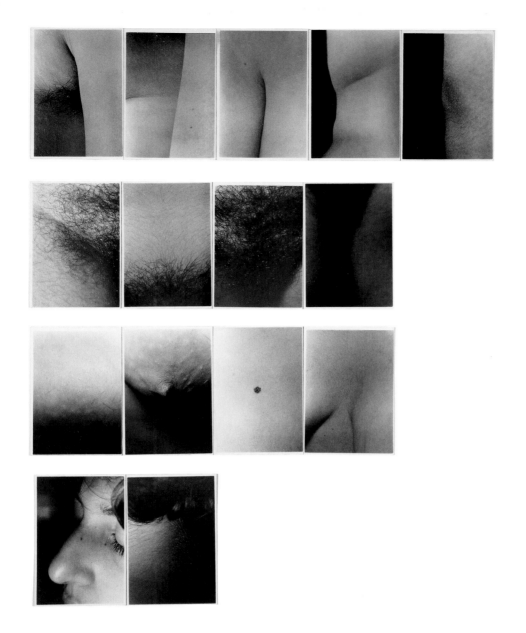

FIG 1
Portrait of El, 1975
15 gelatin silver prints
5 9/16 x 3 3/4 inches (14.1 x 9.5 cm) each

student work the hand is really not educated, but so what, so long as the vision is already there. So that's how I teach. I ask, is the work functioning or not? If it's not functioning for the artist then they have to learn how to make it work. I think all art is like that. The problem with photography is that often it's too technical. The technical comes before the vision or before the idea. The students question, "Is my negative correct?" The word "correct" should not really apply at any time to art. It's just about an idea. You need to work out how to realize the idea first.

In a way I'm always pitting myself against all the modernists who experimented with form when they were making portraits. But, although my portraits look somewhat like theirs, I want to bring everything back to Acconci, who used performance as a framework for exploring the event rather than how something looks. Acconci is extremely important; he really changed my life. I first became aware of him when *Artforum* published a piece about his *Seedbed* in the early seventies. I borrowed from Acconci to deal with the issue of my homosexuality in South Africa. I emulated Acconci's ideas about performance, that you make the structure inside of which you can discover something—like Acconci swinging his arm and clicking the camera, and you don't see the arm swinging or the camera clicking, but you see the image that is occurring because of that action. All my earlier pieces are about a scripted performance where something else can occur. I keep coming back to that.

My initial interest in film also came from my desire to construct my own space in which to suspend disbelief. When you are inside the cinema or inside the darkroom you automatically let go. It's seductive in that way. In the late seventies I made films. They're portraits. *Salters Cottages* is a portrait of three people, voyeurs, in a cottage community, which we rented on Long Island. Maya Deren's *Meshes of the Afternoon* and Jean Genet's *Un Chant d'amour* influenced it. My films showed well, but I ran out of my own money. I received a few little grants, but then, once I had to start raising money, I wasn't able to because the funding dried up for independent films. At the time I was working at a photography lab, and I thought that if John and I opened our own studio we would be able to produce our own films, but it didn't really work. The lab took over and I became a successful printer. I was really lost for a few years there. I was taking portraits and painting on them, I kept writing scripts, I wanted to make a feature film. I hated what I was producing. You need to focus in

order to make your work. You can't be a Sunday artist. I think I came back to making work as another person. I needed that period to reinvent myself.

By 1987 I started looking at photography for itself rather than using it to lead me to another medium, like film or painting. In the Caribbean I found some nineteenth-century negatives of insects. I was enamored of the poetry of the amateur scientist-photographer putting a camera to a microscope and fixing the image. There is a quality of awe in the negatives, the magic of seeing the unseen that I was impressed with and that has become an important aspect of all my work. The *Entomologicals* series I made from these negatives are a portrait of that particular scientist, me interpreting the scientist for you (fig. 2). When I am hired as a printer to print somebody else's work I make it my mission to be a kind of catalyst for them. I try really hard to not interpret their work. There was a kind of shocking shift I experienced between printings for hire and printing the nineteenth-century science negatives. There was no control over me. I knew that I could take the negatives into my darkroom and extremely interpret them, like a musician playing a score one hundred years later. Through making the prints I was trying to learn who that scientist was and in a way to play dress-up to become him. But all I found out was about myself. I gave him an identity: mine. All my portraits are self-portraits.

I salvaged thousands of glass-plate negatives in the eighties. I found them at flea markets and garage sales; they were everywhere. I was looking for a botanical equivalent of [Charles Hippolyte] Aubry that I could explore like the insects, but I couldn't find one. John said, "Why don't you make your own botanicals?" So I did (fig. 3). I looked at eighteenth- and nineteenth-century botanical studies for inspiration, and I remembered the time-lapse movies we saw in biology class of a bean sprouting. A lot of the early scientific botanical studies were presented as objective, but they really weren't. The reason why I've been fascinated with scientific language or how scientists make images is that I loved biology class. It was the only class in school in which I was really happy, making those diagrams and drawings.

I was craving an extreme form of authorship. I wasn't trying to be reactionary, but all the art I saw around me was about appropriation. I reacted strongly to Sherrie Levine's act of appropriating Walker Evans as a kind of materialism to make more stuff. And I was not interested in making more stuff. I was interested in making pieces

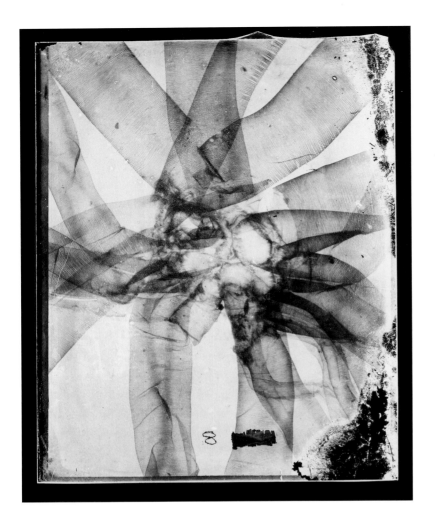

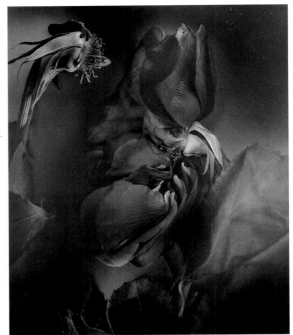

FIG 2
Entomological #3, 1987
Gelatin silver print
36 x 29 inches (91.4 x 73.7 cm)

FIG 3
Rose, 1989
Gelatin silver print
36 x 29 inches (91.4 x 73.7 cm)

that were invested with a private authenticity. But it was the powerful resonance of Levine's ideas that allowed me to focus my own work, and her ideas are still useful for me now. Because of the insect photographs, I felt that in order to go back to a more private space I needed to go back to the nineteenth century, to the beginning of photography. At that time I felt [that] interest in the private gesture was lost in contemporary art. If I was going to relocate that personal space for myself I needed to go look at the work of photographers like Julia Margaret Cameron.

What did Julia Margaret Cameron do? She made portraits using very large wet-plate negatives, and the process was a very slow process. Can you imagine staying still, even if you were clamped into place, for ten minutes? It's pretty intense . . . something happens. The subjects in Cameron's portraits feel very present, especially the children; you see strong emotion, sometimes hatred of Cameron for putting them through this. How do you make a durational portrait? You just have the lens open for half an hour and you work out how to light it within that period of time. All the stuff that I learned about what the face would do in a durational portrait is a result of trying to find a new version of making a Julia Margaret Cameron.

But I decided I did not want my subjects to hate me, so I position them on the floor under the camera, like a still life, and make them comfortable. I talk with the subject during the exposure, and I count the duration of light I shine on any given part of the face. They are lying on the floor and I'm literally three inches from their face, studying it, and it's totally dark, it's very intimate (fig. 4). The finished portraits still look awkward. They're definitely not glamorous, but I don't think my subjects look like they hate me. I first experimented on John in 1989. By 1990 I had made two portraits of him, and other friends and I began to question whether this unveiled quality exists in even the most anonymous studio portrait from the nineteenth century because of something other than the length of the exposure. And then I started evolving my ideas about the camera face and what that means, because we are so used to the camera.

I think portraiture is about identity, and how you find identity and what is real, which is hard to talk about these days because there is no such thing as truth or fact. It's an empirical attempt to find something that's real. Because I don't believe that the face can really show us much on the surface of it. We know how to project at

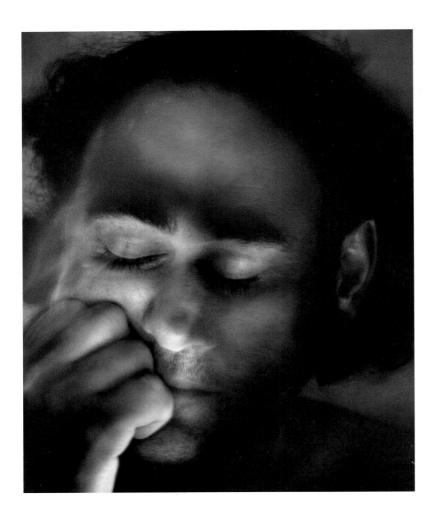

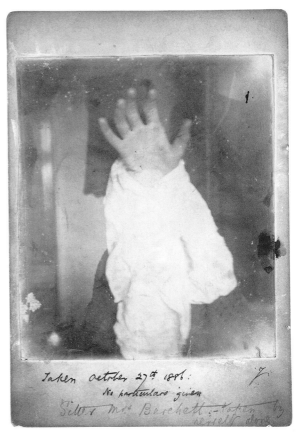

FIG 4
John and Fist, 1992
Gelatin silver print
10 x 8 inches (25.4 x 20.3 cm)

FIG 5
Unidentified photographer
Untitled (spirit photograph), 27 October 1886
Albumen silver print
6 1/2 x 4 1/4 inches (16.5 x 10.8 cm)
Collection of Gary Schneider

the camera, so I found another way to make a portrait that breaks through the camera face. I am most interested in photographing people that I know very well. It's like, okay I know you, you know me. What happens if we go through this process together? My relationship tends to change after I have photographed someone. Photography is like a window, and more gets revealed through the process. That's why I like to photograph myself, because maybe I can learn something more about myself through that process. I photograph John a lot; he's my perfect subject. And he is my biggest critic; he's really tough! I believe that anything I make is flawed. Otherwise why bother to make the next thing? He will always find all the flaws. But it is good for me because I always have all those same questions in the back of my mind. Like: Is it working? Is this right? Am I moving forward?

The nineteenth-century subject wasn't used to the camera or to seeing their portrait in the same way that we are today. I searched for the most plain nineteenth-century studio-portrait negatives I could find. American studios were famous for making the plain portraits with no backgrounds, unfettered by decoration, really. I found a group of portrait negatives of women at a flea market on 26th Street. I used them to make *Carte de Visite*. I edited the negatives to a group of nine portraits, so that the audience would not think that the women were from my family, from my own history. It was obviously something of an established studio that had made them, because of the inventory numbers scratched on the negatives. I think they are New York portraits. They feel incredibly unveiled. What I thought I could bring to them was the contemporary technology of being able to enlarge them to life size and interpret them so that the audience has a theatrical experience, so that they really feel as if they are having a discussion with the women, that they are in the same space.

Spirit photographs also fascinate me. I own one albumen print in a cabinet-card format that depicts a hand with a sleeve that falls off so it looks to be floating. It's not in good shape, but on the back of the card is written: "taken and developed by myself in my own room while quite alone" and then the date (fig. 5). It's very special and it encompasses the whole notion of spirit negatives and photography. I realized the way in which spirit negatives are made is the same way that I montage in the camera. There was a major collection of spirit photographs that came up at auction through Christie's in May 1991, which I acquired. Ada Emma Deane made the

bulk of them at the height of modernism, which also engaged montage techniques. She was active in the 1920s, between the wars in England. I was fascinated too because the audience was so desperate for this particular experience. People were prepared to suspend disbelief—even though some of the spirits are rendered as halftones! I attempted to remake the spirit negatives as contemporary prints, but it wasn't possible; no matter what I did, they still looked too fake to me. They just belong so thoroughly to that particular time that they don't translate into a contemporary context at all.

I'm interested in how to cut through what we assume a portrait is, and I'm interested in creating a private place that questions what is identity in some way. My early work includes a lot of self-portraits where I set the camera on a timer and move before the lens, but by the late 1980s I was not interested in that any longer. The earliest form of portraiture is a hand, and you see it everywhere, from stop signs to children in the playground. So I thought, this is a generic portrait type. So I made my own handprint, and then I used it as if it were a found object, just as I had done with the scientist's negatives. I was able to interpret the print so extremely, to write on top of it excessively in the darkroom. It is a self-portrait, but it's a self-portrait that I could manipulate.

It is an image I borrowed from the caves of Lascaux, the earliest known example of self-identification, the Shroud of Turin, Marcel Duchamp's *Female Fig Leaf*, Yves Klein's body prints, Jasper Johns's *Studies for Skin*, Man Ray's hand on the back of his autobiography, Robert Frank's *Lines of My Hand*. I look at a lot of photography. The wonderful thing about the auctions is that a lot of material that is unpopular is dumped at them, things that you would not see anywhere else. The whole evolution of modernism is process driven, especially the experimental work that came out of ID [Institute of Design] under Moholy-Nagy in Chicago. That particular school was a huge influence on me. You can probably find my handprint somewhere there.

All of the images in my first series of handprints come from one of two negatives. One is a wet-hand and the other is a sweat-hand imprint. It took me forever to work it out, but I knew I wanted a photogram negative. I wanted something that I could print. I needed information that was purely factual, because imprints really are just sweat and heat in the emulsion that I could then use. In that sense they evolved directly from the enlarged microscope slides I had made the year before. As with

all my work, I wanted them to have the sensibility that they were lit from within. It was at the point when I was able to achieve that particular experience with space that I came back to photography. Because, of course, film is about that experience of space and light. That's what I loved about film: you're inside of film's space. I kept thinking I would go back to filmmaking because of that space.

I made *Meditations* first, which is a poetic cycle of four handprints. I thought at the time it was self-indulgent. I didn't want to show it because I thought it needed to have another type of meaning. So I put it into a lockbox, so to speak. But I still had the negatives that I could manipulate. I was losing all of my friends at that time. It's been a really rough ride and a lot of guilt for my generation who are not HIV positive. I lost too many very close friends. Peter Hujar died in 1986; he was the closest, but I already knew people who had died (fig. 6). Ethyl, Peter's closest friend, committed suicide soon after Peter died. He could no longer work. He had been an eccentric, wonderful drag performer. It was just constant at that point. The handprints became for me about the mourning process. I think of them as tone poems, like *Meditations*. Because I've dedicated each handprint to a specific person, it reminds me of that person. Sure, I printed it with that person in mind, but it then becomes inexplicably linked to that particular person. Because each of these photographs begins with my hand imprint, they also become a kind of memory marriage, a glove for that person to inhabit and my way to punch back. I became very possessive of these photographs. I want to know where each one is.

Meditations was an experiment. I was shocked when I pinned it up in the studio that my controlled manipulations of that negative could take me through a kind of mantra. But I felt that *Meditations* was too abstract. It had no overt political, social, or identity content. It could be interpreted in any of those ways or as merely poetic. I think you release work into the world when it can be released. I'm glad I held it back until the Howard Yezerski Gallery show of my work in 1996, called *1993*. 1993 was an important year for me and that was a really major show for me. It included all the tough stuff: *Meditations*, the portraits of my parents, *After Ethyl*, and *Vegetable*, the messiest of the botanicals. This was a dense period of tough emotional and abstract breakthroughs. In the context of this other work, *Meditations* made sense. The only way I could really deal with those handprints was to give them the ultimate emo-

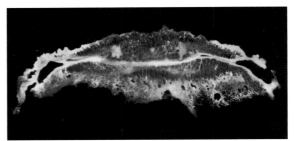

FIG 6
Peter Hujar
John and Gary at Mohonk, 1984
Gelatin silver print
15 x 15 inches (38.1 x 38.1 cm)
Collection of John Erdman and Gary Schneider

FIG 7
John's Lips, 1999
Gelatin silver print
19 ½ x 39 ½ inches (49.5 x 100.3 cm)

tional content. They are memorial portraits, they really are, and why can't they be?

In 1995, I made two versions of *Four Seasons*, a variant of *Meditations*. One is in a private collection and the other is still in my collection. By then I felt confident enough to let the handprints have whatever meaning anyone wanted to read into them. What can you read into those memorial hand portraits? They're very private. You don't know Peter, why would it be called *After Peter*? It's all subjective. In a way, the two *Four Seasons* were like coming back to *Meditations* and saying, this is where I really want to explore. They have to do with the questions of what is expressionism in my work and what is the portrait, what does it really mean to me. Is it really just about my gesture? It's like when I'm making the durational portraits that are so extremely interpreted. Is it really about the subject or is it just all about me? I want to believe that it is that accumulation I talk about. That it's the secretion of all of the expressions they were making during the exposure—what they were thinking, what they were feeling, or what they were projecting. It's all there. But of course there is so much interpretation going on in the printing and in the camera.

John's cousin is a hand surgeon, and he came to my 1995 show at P.P.O.W. that included the memorial handprints. He said, "Why are you making these handprints of just you? Why don't you do other people as well?" And I thought, first of all, the negatives were impossible and they required total darkness in the studio to make. The dry one literally took an hour and a half for me to get enough sweat into the emulsion. But I thought it was an amazing idea. So I researched the available technologies until I found a material, an authocromatic film, which allows me to use a safe light and is very fast. You can't ask someone to be in the darkroom for an hour and a half —it doesn't work. So I worked out a technique that is repeatable and is fast. This kind of impregnating of the emulsion then became part of my repertory. That's also how I made *Mask* and the *Lips* and the *Ears* from *Genetic Self-Portrait*. And that's how I made *John's Lips*, 1999, too (fig. 7).

I could even use the technique with children, because the exposure could be as short as a minute and a half. *Chloe*, 1996, is a two-year-old girl staying still for a minute and a half (plate 30). It's really an amazing handprint. You really feel her presence. You realize in looking at the handprints in relation to each other that there is so much about the gesture that the subject brings to the process that it really is a

portrait. There is so much information in those hands, from those glowing areas that are just heat and sweat, to the actual imprint itself, to the outline. I think all my work is about how to balance what I think of as fact with interpretation or expression. I always imprint the left hand because that's the one I chose for my own hand imprints in 1993, because I needed my right hand to manipulate the process. Then I rationalized the choice, saying most people are right-handed, therefore the left hand is more passive; it can stay still for a minute and a half. The family handprints are the only body of work that I just want to make more and more because each one is so different, such a different gesture, even though I use exactly the same process.

In 1997, I brought my hand imprints into *Genetic Self-Portrait* because I realized that *Genetic Self-Portrait* was not about the genome at all; it was about the forensic sciences for me. It's about privacy. These are my most private parts. Everything I've done is about privacy. A portrait is a contract about privacy. It's about giving up or stealing the identity of the subject. Portraiture is a theft. It's a contract. I enter in to a contract where I'm facilitating the subject's giving up their privacy with their consent. The hand is the most private thing: the fingerprint, the gesture. A lot of people who see those handprints want to read into them the personality of the subject; it's automatic.

Genetic Self-Portrait included everything I had done up to that moment except the faces. It deals with my issues of privacy and narcissism. There is one image excluded from it because of a deadline, the MRI of my brain. This should have been my next portrait, exploring the nature of the brain. But after such intense collaborations with the scientists for *Genetic Self-Portrait*, I needed to go back to a way of making my work that was totally controlled by me. I really focused the hand imprints, which I had been making since 1996. That's when the writer Lynne Tillman approached me about making a book based on the hand imprints. In a way, *Genetic Self-Portrait* interrupted that *Handbook*.

A collector offered to facilitate *Genetic Self-Portrait*, and it was too big an opportunity to pass up. I'm really pleased that I did it, although it exhausted every aspect of my life. It took an enormous amount of will to keep going for eighteen months. I felt incredibly alone, although I must say I loved working with the scientists who gave me their time and their material. They were very generous. My reaction to the material that the scientists provided was similar to what my reaction had been to the nineteenth-century scientific photographic negatives. But I truly believed I had

nothing until I had something. And I only had something once I had assembled all the critical images. I really wanted specimens that functioned in the forensic world. I'm very interested in forensic science because it's about fact. It's all about fact identity or what we believe is fact. I'm always interested in what we currently believe is fact, and the whole evolution of fact into what we now know is fiction. I love that evolution, especially in the history of photography.

When the collector first came to me and said, "I will facilitate a response to the Human Genome Project," I asked, "What is the Human Genome Project?" and he explained it to me. In an hour's time it became clear that for me the possibilities were not about the genome, because that was still too abstract, but in genetics. I could make a self-portrait of my biological information that was diagnostic. I love biology, and I realized I wanted to see my own biology. I mean, what do my chromosomes look like? What are they? I always assumed that chromosomes were digitally produced, like some kind of rendering or drawing, that they were not something that you could actually see through a microscope (fig. 8). It was too amazing, just like the nineteenth-century scientist who made my found negatives; I was looking through a microscope and fixing that information to interpret later. I think that many people would expect photographs made from scientific negatives and made as a response to the Human Genome Project to look scientific. But *Genetic Self-Portrait* is all about the history of image-making through a pictorial eye.

I stopped making the durational portraits before I started making *Genetic Self-Portrait*. The last one is dated 1995. I thought I was done with that type of camera portrait until I began the large color heads. I think the portrait of Peyton is a link to the color portraits, and maybe the [portrait of] Heinz. Heinz just stays so damn still. I always have to direct him to move: smile, lick your lips, and blink your eyes. Otherwise the resulting photograph can feel dead, and I want it to feel very active. I love color. Look how much color I always pumped into my black-and-white photographs through the toning process. It took me two years to make the first large color head print; I really struggled. I started shooting chromes with the intention of making pigment prints. They are my favorite prints in the history of photography, especially Josef Sudek's pigment prints. I tried to render the color portraits as digital pigment prints, but I could not get the volumes inside of the tones that I wanted. So

FIG 8
Y Chromosome, from *Genetic Self-Portrait*, 1997
Platinum/palladium print
5 3/8 x 3 13/16 inches (13.6 x 9.7 cm)

I have the 10-by-8-inch chromes scanned and really play with the contrast and color in Photoshop and then enlarge them as Lambda prints on Fuji Crystal Archive paper. This is the first time I am working with other technicians to make my prints.

With these color portraits the exposures are only about ten minutes, and the portrait is more recognizable. There is a very specific order in which I photograph each part of the face. I start with the forehead, then I do the hair, then I do the right eye, then I do the right side of the nose, then I do the right cheek, then I do the lips, and then the chin, and the left cheek, the left nose, the left eye, and then I sort of outline it slightly, and that's it. There is no ground. With *Heinz* there is a little bit of neck because that's how his face is structured. With *Helen* there is a lot of movement because she literally coughed after I did the one eye. Her right eye is raised up and the face is very distorted. I think that because of the similarity in how I stage and execute the color portraits, more amazing differences occur between the final portraits.

Scale in my work is particular for each body of work. My process limits the size of my prints. I am only able to print and do the kind of intense toning I do in silver prints up to 40 by 30 inches. If I need to print larger, then I create multiple panel installations. I choose the size by how I want to experience the work. If I print the work in different sizes, then I reinterpret it so that it functions best in that size. *Heinz* and *John in Sixteen Parts* were so important to me because I was trying to get back to the cinema, to that particular experience of entering space. Most contemporary photographs of that scale are not about pictorial space; rather, they are about fact. There is no pictorial or plastic experience of space in them. With the new color work the prints are as large as the medium will bear. I like setting myself a challenge. I chose the scale of the large color portraits based on what my chromes would look like in the largest possible scale, so that I could dream into them, like dreaming into a movie screen or being inside a microscope.

I am always searching for something that's going to clarify things for me, like how the world works or how people interact with me. I tend to overanalyze. Why is this occurring? Why did someone say that? You can never really work out what motivates someone else. You can only work out how it affects you.

Selected Exhibition History

One-Person Exhibitions

2003
GENETIC SELF-PORTRAIT
University Art Museum, SUNY, Albany, and University Galleries, University of Florida, Gainesville

PORTRAITS
Julie Saul Gallery, New York

2001
BOTANICAL
Stephen Daiter Gallery, Chicago

HAND MOUTH
Howard Yezerski Gallery, Boston

2000
GENETIC SELF-PORTRAIT
International Center of Photography, New York

SPECIMEN DRAWINGS: PHOTOGRAPHS FROM 1987–1999
Eleanor Barefoot Gallery, New York

1998
GENETIC SELF-PORTRAIT
Musée de l'Elysée, Lausanne, Switzerland

JOHN
Stephen Daiter Gallery, Chicago

INTERFACE
Howard Yezerski Gallery, Boston

1997
GARY SCHNEIDER: RECENT PHOTOGRAPHS
The Haggerty Museum, Marquette University, Milwaukee

PORTRAITS
Garrison Art Center, Garrison, N.Y.

FROM LIFE
P.P.O.W. Gallery, New York

1996
1993
Howard Yezerski Gallery, Boston

1995
PORTRAITS
P.P.O.W. Gallery, New York

1993
BOTANICALS
Robert Klein Gallery, Boston

1992
BOTANICALS
P.P.O.W. Gallery, New York

1991
CARTE DE VISITE
P.P.O.W. Gallery, New York

1977
NAMING
Artists Space, New York

Group Exhibitions

2003
VISIONS AND REVISIONS: ART ON PAPER
Museum of Fine Arts, Boston

À MAINS NUES
Trafic, Frac Haute-Normandie, Sotteville-les-Rouen, France

GENETIC EXPRESSIONS— ART AFTER DNA
Heckscher Museum of Art, Huntington, N.Y.

CARA A CARA
Culturgest, Lisbon, Portugal; Musée de l'Elysée, Lausanne, Switzerland

2002
PANDEMIC
Museum of Contemporary and Visual Art, Barcelona

TRANSLATIONS/ TRANSGRESSIONS
Fine Arts Center Galleries, University of Rhode Island, Kingston

MASK OR MIRROR? A PLAY OF PORTRAITS
Worcester Art Museum, Worcester, Mass.

2001
PARADISE NOW
Tang Museum, Skidmore College, Saratoga, N.Y.

UNDER THE SKIN
Wilhelm Lehmbruck Museum Duisburg, Germany

2000
LE SIÈCLE DU CORPS
Musée de l'Elysée, Lausanne, Switzerland

PARADISE NOW
Exit Art, New York

SURFACE AND DEPTH: THE PORTRAIT IN CONTEMPORARY PHOTOGRAPHY
Hood Museum of Art, Dartmouth College, Hanover, N.H.

FOREIGN BODIES
Untitled (Space), New Haven, Conn.

PHOTO-FORUM 2000
Museum of Fine Arts, Houston, Tex.

WHAT'S NEW: RECENT ACQUISITIONS IN PHOTOGRAPHY
Whitney Museum of American Art, New York

UNNATURAL SCIENCE
MASS MoCA, North Adams, Mass.

PARTICLE ACCELERATORS
Photographic Resource Center, Boston University, Boston

PERSONAE: PORTRAITS FROM THE COLLECTION
Museum of Contemporary Photography, Columbia College, Chicago

A DECADE OF COLLECTING— HARVARD UNIVERSITY ART MUSEUMS
Fogg Art Museum, Harvard University, Cambridge, Mass.

1999

COLLECTION IN CONTEXT—
HENRY BUHL
Fondation Claude Verdan,
Lausanne, Switzerland

HEAD TO TOE: IMPRESSING
THE BODY
Fine Arts Center, University
of Massachusetts, Amherst

REFLECTIONS ON THE ARTIST
National Gallery of Canada,
Ottawa

CENTURY OF THE BODY:
PHOTOWORKS 1900 TO 1999
Culturgest, Lisbon, Portugal

WILD FLOWERS
Katonah Art Museum,
Katonah, N.Y.

1998

COLLECTION IN CONTEXT—
HENRY BUHL
Houston Center for Photogra-
phy, Houston, Tex.; University
of Colorado, Boulder; Univer-
sity of Maryland, Baltimore

THE BODY IN THE MIRROR
The Photographic Center of
Skopelos, Larissa, Greece

OUT OF SIGHT
Santa Barbara Museum, Santa
Barbara, Calif.

THE COTTINGSLEY FAIRIES
AND OTHER APPARITIONS
Memphis Brooks Museum of
Art, Memphis, Tenn.

1997

SCIENTIA ARTIFEX
Museum of Contemporary
Photography, Columbia
College, Chicago

ABOUT FACE
Fogg Art Museum, Harvard
University, Cambridge, Mass.

POETIC EVIDENCE:
SCIENCE IN CONTEMPORARY
PHOTOGRAPHY
National Gallery of Canada,
Ottawa

PAPER SUPPORT: RECENT
ACQUISITIONS—PRINTS,
DRAWINGS, PHOTOGRAPHS
Yale University Art Gallery,
New Haven, Conn.

PROCESS ON PAPER—
RECENT ACQUISITIONS
The Brooklyn Museum,
Brooklyn, N.Y.

BODY ELECTRIC
Winnipeg Art Gallery, Win-
nipeg, Canada, and Musée des
Beaux-Arts, Montreal

FACE VALUE: AMERICAN
PORTRAITS
The Wexner Center for the
Arts, Columbus, Ohio, and
Tampa Museum of Art,
Tampa, Fla.

COLLECTION IN CONTEXT—
HENRY BUHL
Thread Waxing Space, New
York; Parrish Art Museum,
Southampton, N.Y.; and
Ohio Wesleyan University,
Delaware, Ohio

1996

CARTE DE VISITE
installation, Cooper Union,
New York

FACE AND FIGURE
Museum of Fine Arts, Boston

1995

RITUALS AND
TRANSFORMATIONS
National Gallery of Canada,
Ottawa

MOHOLY-NAGY AND PRESENT
COMPANY
Art Institute of Chicago,
Chicago

FACE VALUE: AMERICAN
PORTRAITS
Parrish Art Museum,
Southampton, N.Y.

FACT, FICTION, AND TRUTH:
CONTEMPORARY PORTRAITS
Lehman College Art Gallery,
Bronx, N.Y.

NATURE STUDIES II
Fine Arts Center, University
of Massachusetts, Amherst

1994

FLORA PHOTOGRAPHICA: THE
FLOWER IN PHOTOGRAPHY
FROM 1835 TO THE PRESENT
New York Public Library, New
York; Royal Ontario Museum,
Toronto; and Musée des
Beaux-Arts, Montreal

1993

ABOUT NATURE
Cleveland Center for Contem-
porary Art, Cleveland, Ohio

THE ALTERNATIVE EYE
Southern Alleghenies Museum
of Art, Loretto, Pa.

PHOTOGRAMS AND
PHOTOGRAPHS: ADAM FUSS
AND GARY SCHNEIDER
Blackman Associates, Chicago

OBSERVING TRADITIONS:
CONTEMPORARY
PHOTOGRAPHS 1975–1993
National Gallery of Canada,
Ottawa

I AM THE ENUNCIATOR
Thread Waxing Space, New
York

1991

FROM DESIRE:
A QUEER DIARY
Richard F. Brush Art Gallery,
St. Lawrence University,
Canton, Mass.

1986

NEW YORK, NEW WORK,
NEW YEAR, screening
of SALTERS COTTAGES
The Funnel, Toronto

1984

SALTERS COTTAGES
screened at the Arsenal,
Berlin, and the Metropolis,
Hamburg, Germany

1981

SALTERS COTTAGES
screened at Millennium and
the Collective for Living
Cinema, New York

1979

PERIPHERAL INTERCOURSE
screened at Millennium,
New York

Selected Bibliography

ALETTI, VINCE. "Portfolio: Gary Schneider." *Artforum* 40/1 (September 2001), 175–84.

"The Art of Science." *Doubletake* (Spring 1998), 50–51.

BROKHAUS, CHRISTOPHER. "Gary Schneider." In *Under the Skin: Transformations in Contemporary Art*. Exh. cat. (Wilhelm Lembruck Museum of Art, Duisburg, 2001), 86–91.

CARTER, CURTIS L. "Performance in Photography: Gary Schneider's Photographs." In *Gary Schneider: Recent Photographs*. Exh. cat. (Haggerty Museum of Art, Marquette University, Milwaukee, Wis., 1997), n.p.

DILLON, MARION. "Identities." In *Identities: Contemporary Portraiture*. Exh. cat. (New Jersey Center for Visual Arts, Summit, 2001), 9–10.

EWING, WILLIAM. *The Century of the Body*. London, 2000.

GOLDBERG, VICKI. "The Fine Art of Making the Invisible Visible." *New York Times*, 24 May 1998.

———. "Peering into Places That Mere Eyes Cannot See." *New York Times*, 21 February 1993.

HARKAVY, DONNA, AND MARGARET MATHEWS-BERENSON. *Head to Toe: Impressing the Body*. Exh. cat. (University Gallery, Fine Arts Center, University of Massachusetts, Amherst, 1999).

HEIFERMAN, MARVIN, AND CAROLE KISMARIC. *Paradise Now: Picturing the Genetic Revolution*. Exh. cat. (Exit Art, New York, 2001).

HEON, LAURA STEWARD. *Unnatural Science: An Exhibition*. Exh. cat. (MASS MoCA, North Adams, Mass., 2000).

HOELTZEL, SUSAN. *Fact, Fiction, and Truth: Contemporary Portraits*. Exh. cat. (Lehman College Art Gallery, Bronx, N.Y., 1995).

KAO, DEBORAH MARTIN. "About Face: Artists' Portraits in Photography." In *Harvard University Art Museums Review* 6/2–7/1 [special double issue on "Photography and the Art Museums"] (Fall 1997), 1, 4–5, 18.

———. "Dancing in the Dark(room)." In Gary Schneider, *John in Sixteen Parts*. Worcester, Mass., 1997, n.p.

———. "Light Conversation: Seminars with Contemporary Photographers." In *Harvard University Art Museums Review* 6/2–7/1 [special double issue on "Photography and the Art Museums"] (Fall 1997), 14–15.

KATZ, VINCENT. "Gary Schneider: An Interview." *Print Collector's Newsletter* 27/1 (March–April 1996), 11–14.

KEVLES, BETTYANN HOLTZMANN. "Portrait Without the Camera Face." In Gary Schneider, *Genetic Self-Portrait*. Syracuse, N.Y., 1999, n.p.

LOKE, MARGARET. "Making Artful Images Out of Science." *New York Times*, 25 January 2002.

MARIEN, MARY WARNER. *Photography: A Cultural History*. London, 2002.

MILIOTES, DIANE. *Surface and Depth: Trends in Contemporary Portrait Photography*. Exh. cat. (Hood Museum of Art, Hanover, N.H., 2000).

NAISBITT, JOHN. *High Tech/High Touch*. New York, 1999.

PAULI, LORI. *Reflections on the Artist: Portraits and Self-Portraits*. Exh. cat. (National Gallery of Canada, Ottawa, 1999).

————. "Warm Hands, Cold Eye: Gary Schneider's Dissection of the Self-Portrait." In Gary Schneider, *Genetic Self-Portrait*. Syracuse, N.Y., 1999, n.p.

POLLACK, BARBARA. "On the Edge: The Genetic Esthetic." *Artnews* 99/4 (April 2000), 133–37.

SCHNEIDER, GARY. *Botanicals*. Exh. cat. (Stephen Daiter Gallery, Chicago, 2001).

————. *Genetic Self-Portrait*. Syracuse, N.Y., 1999.

————. *John in Sixteen Parts*. Worcester, Mass., 1997.

————. *Yezerski Family Portrait*. Boston, 2001.

SEDOFSKY, LAUREN. "Gary Schneider's Photographs: Through Glass Darkly." *Artforum* 33/7 (March 1995), 68–73.

SINSHEIMER, KAREN. *Out of Sight: Imaging/Imagining Science*. Exh. cat. (Santa Barbara Museum of Art, Santa Barbara, Calif., 1998).

SMITH, ROBERTA. "Galleries Are Labs of a Sort." *New York Times*, 14 February 1999.

————. "Gary Schneider." *New York Times*, 4 April 2003.

THOMAS, ANN. "The Portrait in the Age of Genetic Mapping." In Gary Schneider, *Genetic Self-Portrait*. Syracuse, N.Y., 1999, n.p.

TILLMAN, LYNNE. *This Is Not It*. New York, 2002.

"The 2000 Alfred Eisenstaedt Awards, Science Essay Winner, Best Essay Depicting Science or Technology, 'Gary Schneider Inside Out.'" *Life* (Spring 2000), cover, 36–37.

VON ZIEGESAR, PETER. "Gary Schneider at P.P.O.W." *Art in America* 83/10 (October 1995), 122.

WILFORD, JOHN NOBLE. "Inside Out: Genetic Self-Portrait by Gary Schneider." *New York Times Magazine*, 17 October 1999, 106–13.

WOODWORD, RICHARD B. "Gary Schneider." *Artnews* 97/2 (February 1998), 121.